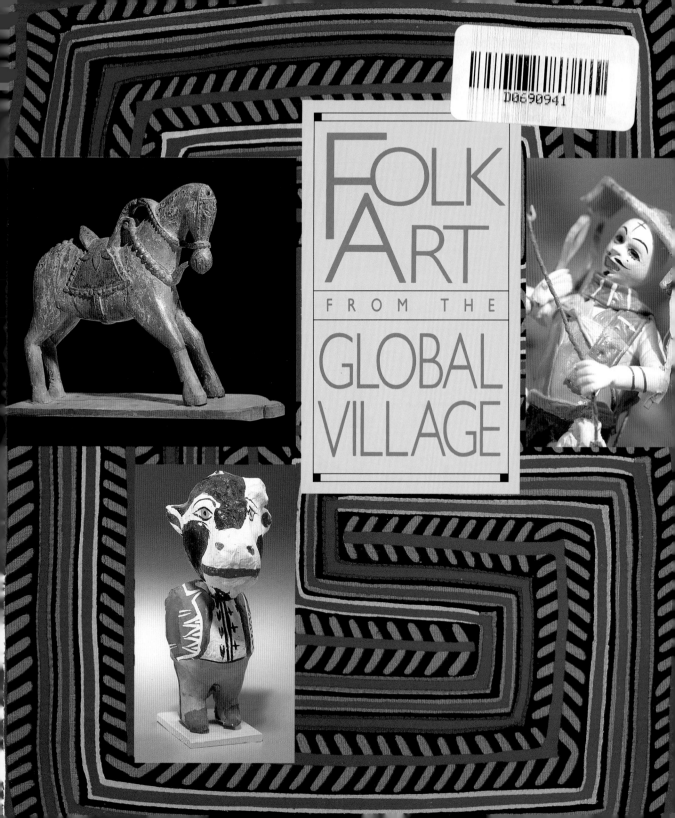

# FOLK ART
## FROM THE
# GLOBAL VILLAGE

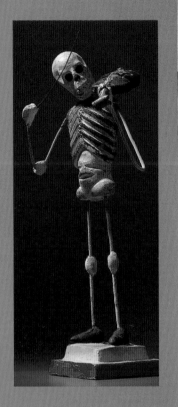

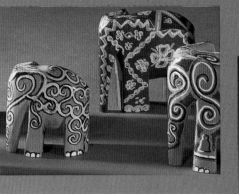

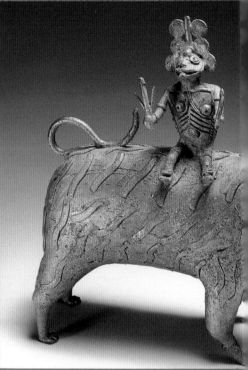

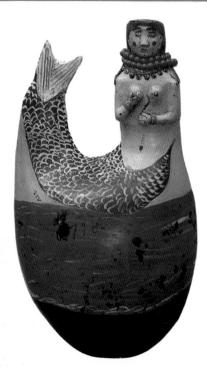

ESSAY BY JACK LENOR LARSEN

# Folk Art
## from the
# Global Village

### The Girard Collection
### at the Museum of
### International Folk Art

Museum of New Mexico Press · Santa Fe

SECTION OPENERS: Sun screen print design by Alexander Girard.

FRONT COVER: Christening Scene (detail), by the Aguilar Family, Ocotlán de Morelos, Oaxaca, Mexico, c. 1960.

BACK COVER: (Top) Cardinal Rising from Fruit, San Pedro Tlaquepaque, Jalisco, Mexico, c. 1970. (Middle) Chalkware Cat, Pennsylvania, United States, late twentieth century. (Bottom) Horse Bank, San Pedro Tlaquepaque, Jalisco, Mexico, c. 1932.

PAGE 1 (UNNUMBERED): Kuna *Mola* (appliquéd blouse panel), San Blas Islands, Panama, twentieth century.

PAGE 3 (UNNUMBERED): Wedding Blouse (detail), Sind, Pakistan, early twentieth century.

All objects are from the Girard Foundation Collection at the Museum of International Folk Art in Santa Fe, New Mexico. The Museum of International Folk Art and the Museum of New Mexico Press are units of the Museum of New Mexico, a division of the State Office of Cultural Affairs.

Project editor: Mary Wachs

Designer: Jos. Trautwein, The Bookmakers Studio

Photography: Michel Monteaux (exceptions noted)

Typography: Set in Sabon and Univers by Wilsted & Taylor, Oakland

Text contributions by Museum of International Folk Art staff:
Charlene Cerny, Director
Nora Fisher, Curator of Textiles and Costumes
Frank J. Korom, Curator of Asian and Middle Eastern Collections
Judy Chiba Smith, Curator of American and European Collections
Former staff: Christine Mather, James Pahl, Mary Jane Schumacher, and Carol Steiro

Library of Congress Cataloguing-in-Publication Data available.

ISBN 0-89013-464-2

Manufactured in Korea
10  9  8  7  6  5  4  3  2  1

MUSEUM OF NEW MEXICO PRESS
Post Office Box 2087
Santa Fe, New Mexico 87504

# AN APPRECIATION

## by Charlene Cerny

Director, Museum of International Folk Art

With the passing of Alexander "Sandro" Girard, the Museum of New Mexico lost one of its most generous patrons and donors. In 1978 it was Girard who, along with his wife Susan, quintupled the size of the Museum of International Folk Art's collection with one sweep of the pen. The gift of the vast 106,000-piece Girard collection, ably negotiated by the then-director of the museum, Dr. Yvonne Lange, is the largest the Museum of New Mexico has ever received in its eighty-three-year history.

I first became acquainted with Girard indirectly, through his internationally acclaimed design work. Though it occurred in the early 1960s, I remember it well: I was on my first Big Date, at the chic new restaurant La Fonda del Sol, located in New York's Time-Life Building. It was not long before I found myself swooning not at the fresh-faced young man sitting across the table but at the gorgeous interior to which Alexander Girard had given life. Infused with the spirit of a Latin American fiesta, La Fonda del Sol combined extraordinary examples of folk art (none of us had ever seen such things!), an open hearth, exotic spices and smells, bold graphics, gleaming brass and tile, and sensuous ribbons. The colors—Chinese red, hot pink—were almost unimaginable in that bland, beige era.

Girard's design vision reached far beyond La Fonda del Sol, but, throughout, his work suggested that rules of taste are made to be broken and that confident personal expression, joy, spontaneity, and informality are values to be celebrated. Such ideas are by now accepted and even canonized—but they transformed the way we as Americans live, entertain, and regard ourselves.

It is as a collector and premier magician of exhibition design that Girard will be best remembered in the world of folk art. Sandro's wit and mischievous personality are nowhere more evident than in his design and installation of the Girard Wing, perhaps his greatest legacy. Since the opening of the wing in 1982 more than a million and a half visitors of all ages have delighted in the unforgettable vignettes that Sandro invented. Where else can we share in the raw excitement of a bullfight, join somber mourners at the wake of a Mexican villager, experience the sheer pleasure at discovering the perfect toy shop, or permit ourselves the zaniness of having a teddy bear to Christmas lunch? Only in the Girard Wing.

So it is for the joyous gift that Sandro continues to give to all of us that we dedicate this book to his memory.

Plates, Tonalá, Jalisco, Mexico, c. 1960.

# FOREWORD

by Alexander H. Girard (1907–1993)

In my earliest days I became very aware of Christmas. The nativity groups, miniature to life-size, that abounded in Florentine churches are lodged in my earliest memories.

Aware of my addiction, my parents or someone in the household took me on a tour of all those that existed. The life-size nativity at the Church of the Santissima Annunziata mesmerized me, as I thought the figures were real people.

It was not long before I began to assemble my own crèches from pieces given to me. Each year they became more elaborate and complicated and the settings more ambitious. Later, my American grandfather gave me one which was badly damaged, as an exercise in restoration. Restored again, by an expert, it is now in the Girard Foundation Collection at the Museum of International Folk Art in Santa Fe, New Mexico.

My fascination with miniatures grew and grew. Travel, generous friends, and relatives offered endless opportunities to collect. A childhood beginning of collecting blossomed and expanded.

The discipline of architectural training, and growing up, added new dimensions. An infant's toy became human expression. I was surrounded by it—*folk art*.

The collection grew with my maturing and it expanded with my awareness. It was international, it had differences, it was a spectrum of mankind, it was bewilderingly varied and aston-

ishingly related. It offered connections which resulted in more profound understanding.

An old Italian proverb says, *Tutto il mondo e paese*, "the whole world is hometown." The whole world *must* know about itself. Folk art tells us there are no "foreigners." The colors vary, their languages vary, but their spirits and aspirations are interwoven into one incredibly rich humanity.

As human necessities and purposes change, whole worlds die—and new scenes, customs, and beautiful things are born. Yet, no matter how exciting the discoveries each generation makes for itself, it is always painful to see the past vanish, taking parts of us with it.

In most of us there is a tendency to try to halt time, to relive the past through the accumulation of souvenirs, to which we cling as a child might cling to an old doll. We treasure artifacts that remind us of people we once knew and loved, and we add to our collection objects of many kinds, which we identify with a past or with a way of life that we would like to see perpetuated . . . somehow.

The "handcraft" civilization is rapidly disappearing, and we delude ourselves if we think that artificial means can keep this highly individual form of expression alive as an organic part of our present society. Technology constantly changes our way of life and forms of expression.

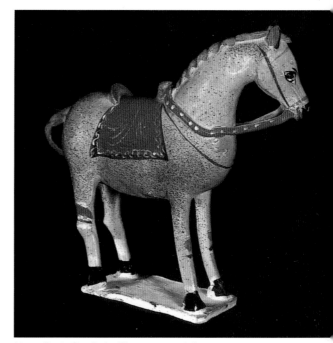

Horse Bank, San Pedro Tlaquepaque, Jalisco, Mexico, c. 1932.

Yet we can, and I firmly believe we should, preserve evidence of the past, not as a pattern for sentimental imitation, but as nourishment for the creative spirit of the present, so that we too may evolve customs and shape objects of equivalent value in our own way, in our own time, taking advantage of the many new methods and materials at our disposal. In this way we will neither ignore nor forget the spirit of individuals who have died, the spirit of a people. We will remember them by their unique voices, which echo still out of their creations, and we will be inspired by them.

# INTRODUCTION

### by James Pahl

Former Assistant Director
Museum of International Folk Art

The unique quality of the Girard Foundation Collection, portions of which are on permanent exhibit at the Museum of International Folk Art, in Santa Fe, lies not only in its focus on the more ephemeral artistic expressions of man, but also in the collecting parameters themselves. During a period of fifty years, Alexander and Susan Girard assembled a remarkable collection of some 106,000 objects that represent the folk arts of over one hundred countries in what is the largest cross-cultural folk art collection in the world. These objects were selected to illustrate mankind's universal need to give form to a sense of ornament, play, delight, and wonder.

Many areas of special strength and importance within this vast collection are presented in the pages that follow. Among the textiles in the collection, most notable are the twentieth-century sub-Saharan and West African works, European samplers from the eighteenth and nineteenth centuries, and an exceptionally fine collection of *molas* (appliquéd blouse panels) from the San Blas Islands of Panama. Also of major importance is the religious and devotional art: ex-votos, talismans, and amulets from eighteen distinct countries; *retablos* and *bultos* from both Mexico and New Mexico; and nativities from around the world. Particular emphasis is placed on Mexi-

can and Peruvian works. The figurative ceramics from Latin America constitute the largest numerical segment of the Girard collection. Toys have, of course, been a central part of the collection from its inception. Indeed, the collection began informally with Mr. Girard's acquisition of a splatter-paint Mexican coin-bank horse. There are delightful puppets from India, Indonesia, China, Taiwan, France, Italy, Poland, and Russia. Other theater-related materials include numerous juvenile drama sets and characters dating from the late eighteenth century through the mid-nineteenth century. Finally, this all-too-brief listing of highlights must include mention of the Girards' interest in the American Southwest as evidenced by the large selection of Navajo geometric weavings, Cordova woodcarvings, and Cochiti ceramics.

Alexander Girard, a leading architect and interior and textile designer in the second half of this century, designed the permanent exhibition "Multiple Visions: A Common Bond," which displays more than 10,000 pieces from the collection in the Girard Wing at the Museum of International Folk Art. More than a million visitors have passed through the doors into the special world of Girard since the exhibition opened in 1982.

Huichol Yarn Painting (details),
Nayarit or Jalisco,
Mexico, c. 1978.

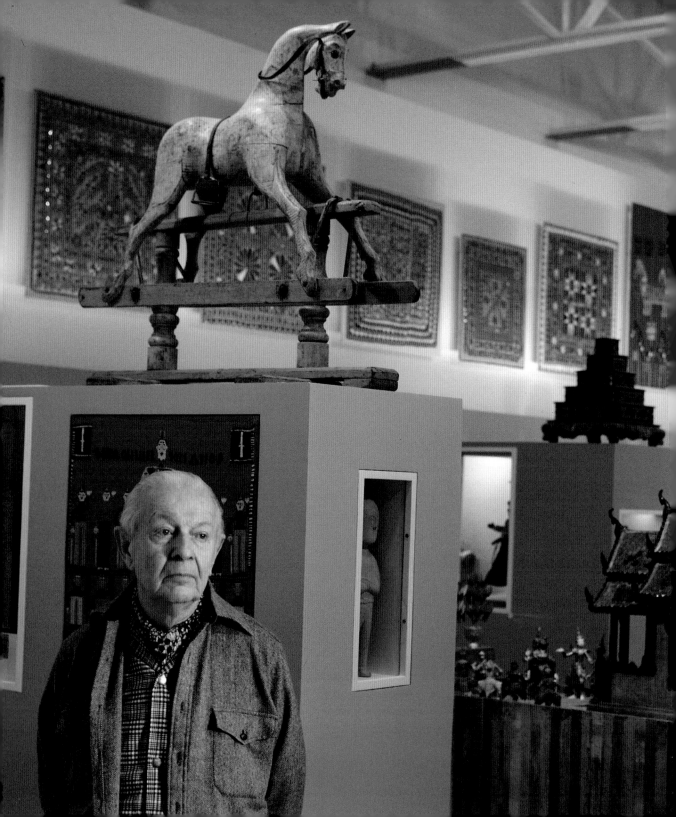

Alexander H. Girard, born 1907 New York City, raised in Florence, Italy. Studied architecture in Europe and America, then practiced on both continents before opening offices in New York (1932), Detroit (1937), and Santa Fe (1953). Early projects included corporate offices and plant interiors for Detrola Corporation in Detroit (1943); Ford Motor Company offices in Dearborn, Michigan (1946); and the Girard family residence at Grosse Pointe, Michigan (1948).

Exhibition design at The Museum of Modern Art, New York, included "Good Design" Home Furnishings Exhibit (1954) and "Textiles and Ornamental Arts of India" (1955); and "For Modern Living" at Detroit Institute of Arts (1949). Other major installations included the exhibit "The Magic of a People," HemisFair '68, in San Antonio, Texas.

Director of textile division of Herman Miller, Inc., from 1952. Girard fabric designs exhibited at MoMA, Whitney Museum of American Art, and other museums in the United States and abroad.

Preeminent interior projects included J. Irwin Miller residence in Columbus, Indiana (1955); Herman Miller, Inc. showroom, San Francisco (1958); Herman Miller Textiles and Objects Shop, New York (1961). Major restaurant interiors: La Fonda de Sol (1960) and L'Etoile, in the Sherry Netherlands Hotel (1965), both in New York, and The Compound, Santa Fe, New Mexico (1966). Directed the total design of Braniff International from 1964. His consummate assignment, the installation of "Multiple Visions: A Common Bond" for the Girard Wing at the Museum of International Folk Art, completed in 1982. Died in Santa Fe, New Mexico, 1993.

Alexander Girard in the Girard Wing during final installation, Santa Fe, 1982.

# A CELEBRATION OF THE SENSES
## by Jack Lenor Larsen

Alexander "Sandro" Girard's career can be summed up as a long, single-handed campaign to inject the lively human qualities of joy and spontaneity into what was probably one of the driest, sensually impoverished chapters in the history of design. All through the four decades when architectural catholicism was measured by the omission of all emotional aspects, when serious environmental design had not healed our alienation from senses (and, often, sensibilities) but had made a headstrong plunge into judgmental functionalism, Girard was foremost in suggesting the alternative of a lively, *personal* expression. That Girard's reputation is not higher than it now is can be traced to several factors. Although he designed chairs for some projects, none figure in that succession of classic seating by which twentieth-century designers are measured. Of his interiors, too few remain as he designed them; only a handful hold up to black-and-white photography by which (particu-

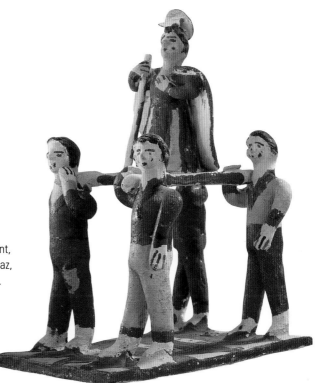

Man Carrying a Saint,
Rabinal, Baja Verapaz,
Guatemala, c. 1965.

larly) International Style projects are remembered. Because Frank Lloyd
Wright, Mies van der Rohe, Corbusier, and Kahn orchestrated space
through black-and-white drawings, many of their finest works read per-
fectly well in colorless photo images. Not so Girard, who brought to
projects not only spatial organization but popular theater. How could
one photograph convey his playfulness? Or, in black and white, his color
orchestrated in the full round? Or his celebration of food? Or a fiesta?

It's not that Girard was an "outsider." He was not; rather, he was both
honored in his time and much published. He was also sought out to
design all manner of installations by the corporate and cultural leaders
of his day. His friends, colleagues, and clients were peerless. Sandro and
Susan Girard lived well; they were more social than most designers
then or now. In short, Girard was something akin to the real hero of the
Spanish-American War—not a forgotten admiral or rough-riding general

but the genius who overcame yellow fever and, so, affected the world's population—for all time.

If there probably was not one keystone in the high arch of mid-century designers, Alexander Girard was a unique and indispensable wedge of it. His only counterparts, who also viewed with tongue and cheek the urgency of modernist dictum, were probably that other Alexander— Calder, and Saul Steinberg. Both had shared with Girard rich doses of

The Girard living room in Grosse Pointe, Michigan, 1948. Photo by Elmer Astleford.

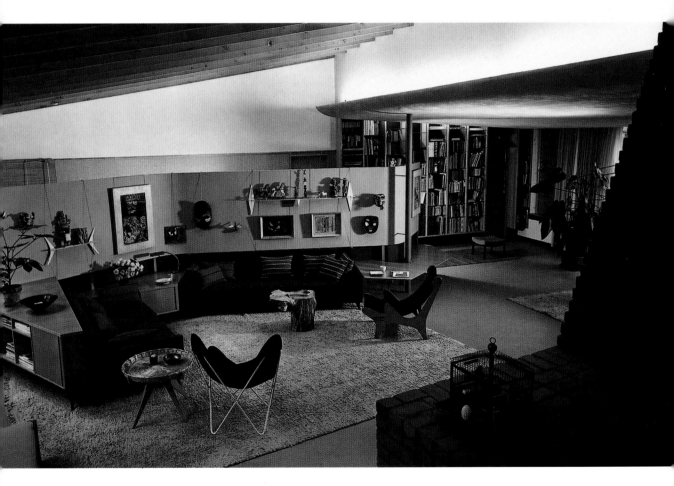

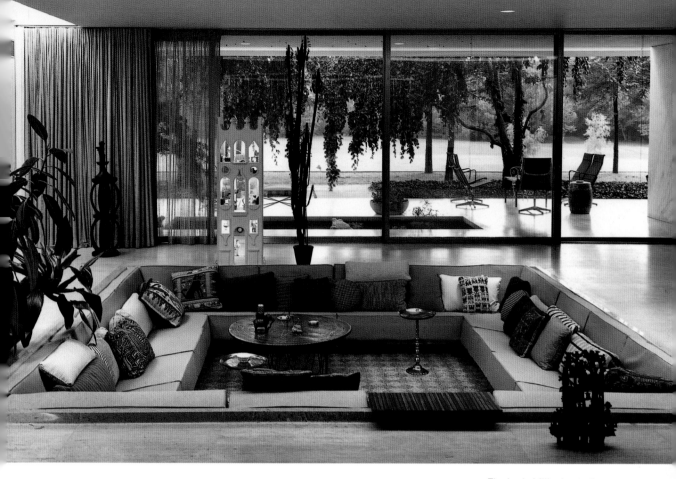

The Irwin Miller house in Columbus, Indiana, 1955. Interiors by Girard. Photo by Ezra Stoller.

continental lifestyle and a propensity for chuckles—particularly about themselves.

But, if individuals are to be named in relation to Girard the designer, George Nelson and Ray and Charles Eames must be first. Together they formed the complementary triumvirate at Herman Miller, Inc., the manufacturer of modern furniture, all through the productive decades following WWII. Nelson, a probing, Socratic intellectual with a penetrating analysis of not apparent but underlying realities, broke through conventions so as to create the interior landscapes in which we live and work. He so clearly and convincingly envisioned "the big picture" ahead as to influence our course through it.

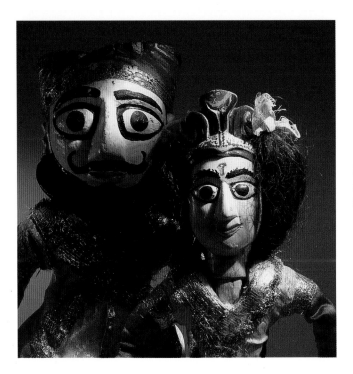

Marionettes: Sword Fighter and Dancer (details), State of Rajasthan, India, c. 1900.

In the furniture and exhibit design and in their durably pertinent series of films, the Eameses were at least as visionary as Nelson. Unlike him, their media did not include the written word. Rather, these were humanists comfortable in probing and shaping a neo-organic world beyond cutting-edge technology. Their genius lay in never being out of touch with human nature. The sensual delights and simple pleasures that remain an innermost commonality of all peoples seamlessly especially bonded them to Girard's compassionate view of life. Together Charles and Sandro sought out sources of folk art; and it was Charles's camera which most sensitively captured the spirit of Girard's installations.

Over a ten-year period in New York (1956–1966) three "food assignments" electrified a public that had known Girard primarily as a fabric-designing insider of the new purist cult and as an exhibition designer for the Museum of Modern Art. There, even more than his installations for the "Good Design" shows, his brilliant, extravagant "set" for "Textiles and Ornamental Arts of India" (1955) should have given us a clue to the bombast to follow.

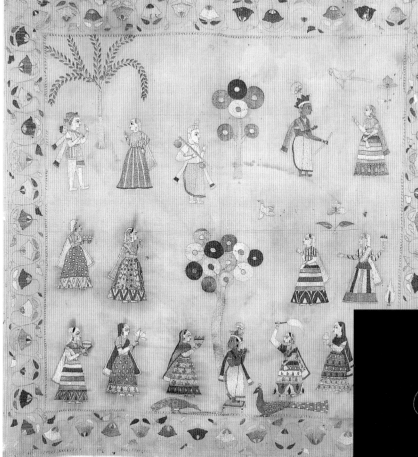

Chamba *Rumal* (embroidered coverlet), Himachal Pradesh, Chamba, India, nineteenth century.

Embroidered Bag, Gajarat, India, c. 1960.

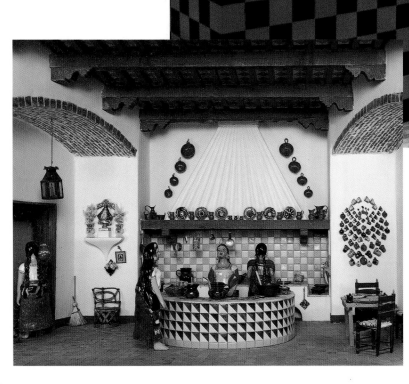

La Fonda del Sol restaurant, 1960.
Photo by Charles Eames.

Mexican Kitchen, assembled and
designed by Alexander Girard,
twentieth century.

In 1956, Girard was commissioned to design seven table-top environments for Georg Jensen, Inc. This history-making demonstration heralded a whole new attitude toward the sensual and social pleasures of dining. His welcome message was that hospitality has no rules but must incorporate such important elements as surprise and spontaneity, ritual and nostalgia, consideration and celebration, and design and form. Sandro Girard's underlying proposition was becoming clearer; he was urging us to celebrate (not stifle with intellectualized precepts) areas that innately belong to the senses. In these areas more *is* more.

Girard's approach at La Fonda del Sol was revolutionary. Its *design* was grand—total, expansive, complete to the buttons on the waiters' jackets—but the spirit was as inclusive as a fiesta. Families came; so did actors, designers, executives, foreigners, and young people out on a "big date." They came for the exotic foods of Latin America, the joyous folk art celebration, but mostly for the ambience. All these ideas were Girard's, from the Spanish-American concepts to the exposed grills of sparkling tile, to his exotic china, evocative menus, and the powerfully articulated brass sun. High overhead stretched an acre of the best ceiling light grid yet designed. Beneath it the bar was enclosed in adobe, pierced for vignettes of the most extraordinary folk art ever to grace commerce. The windows were screened with golden layers of wide, tautly stretched ribbons. These ribbons, warp knit of such improbable combinations as jute and Lurex, with a dozen or more variations, were—then as now—without precedent or peer.

Throughout La Fonda del Sol, color and light were used to create a dozen moods. So were the spaces from the horizontal and open to those enclosed by parapets and canopies. Fabrics, particularly a variety of striped Miller wools, supported this orchestration. Miller solid-colored upholsteries varied the hundreds of Eames dining chairs—the one constant, unifying denominator. When Girard's "other restaurant," L'Etoile,

opened five years later in New York, its contrast with La Fonda and with all that the world had come to expect from Girard was pure genius. Virtually without color, without Latin or folkloric overtones, its mood was coolly chaste. The dramatic understatement, involving light and surface, dull grays with sparkling whites, was, although it predated the revival of Art Deco, reminiscent of pre-war Parisian urbanity, particularly of the French ocean liner *Normandie*.

Although L'Etoile and La Fonda have long since closed, they deserve more focus than these few lines, for these environments were more than food and decor, more than a business. To thousands of people who experienced these spaces, it was a life-expanding revelation that creative, zestful informality was more convivial than "company manners." That this quality of design was out of a museum context and in actual use made it that much more influential. However, the most important statement, more durable than the totality of the planning, the props, or the color, was the assertion that the prime concern of environmental design was how people *feel* in a space. This is Girard's message and main contribution.

At a time when modern architecture was rapidly becoming a larger, more standardized aspect of the corporate establishment, the success of La Fonda whetted our appetites for more romantic, diversified interiors, particularly in nonwork areas. We wanted to see more Girard design. This opportunity came when a Herman Miller showplace, T & O (Textiles and Objects), opened on Manhattan's East 53rd Street in 1961. The textiles included new ranges of nongeometric handprints and earthy wool upholsteries. Since the objects were lavish folk art pieces selected and displayed by Girard, the interrelationship of textiles and objects was inevitable.

His total design for Braniff International, beginning in 1964, brought Girard's design (and Braniff) to the attention of a very broad audience.

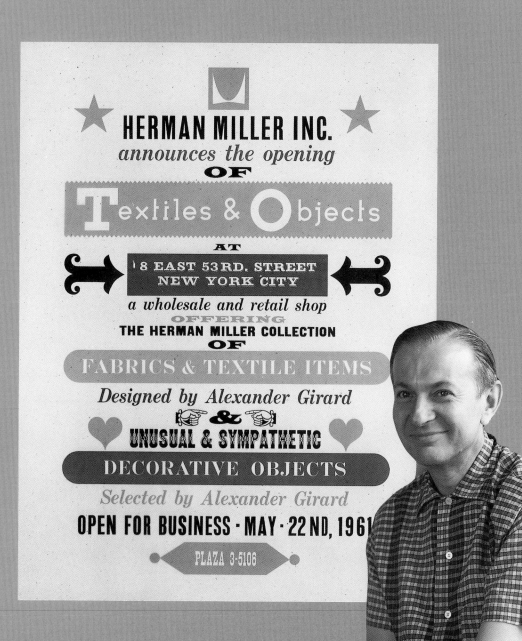

Girard in the early 1950s; poster created for 1961 opening of Herman Miller Textiles & Objects Shop in New York. Portrait by Charles Eames.

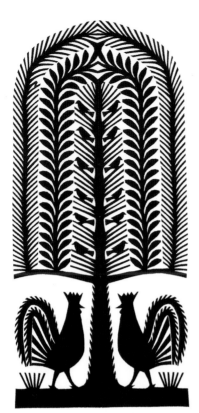

The Tree of Life/*Leluja*,
Kurpie region,
Poland, c. 1962.

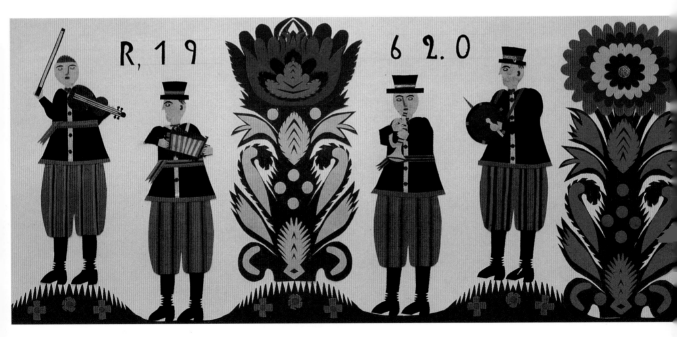

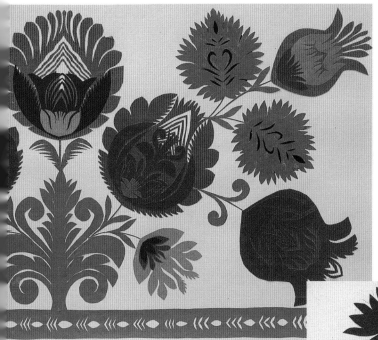

Paper Cut-out, by Helena Selenda, Chasno, Łowicz, Poland, c. 1962.

Rooster, by Marianna Pietrzak, Łowicz, Poland, 1962.

Musicians, by Zofia Wiankowska, Niespusza Nowa, Łowicz, Poland, dated 1962.

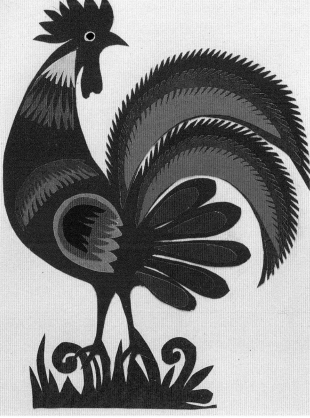

Sign of the Watchmaker,
West Africa, c. 1970.

History Professor, by Izúcar de Matamoros, Puebla, Mexico, c. 1960.

General Potowski, by Jan Lameski, Poland, c. 1960.

Screen prints created by Girard for Herman Miller in the early 1950s. Photos by Charles Eames.

It startled a generation into the awareness that even the look-alikes of mass transit could—through color and pattern—achieve metamorphosis. While other designers wondered where to put which exterior color, Girard bathed entire planes in the sunniest of hues—and a variety of hues at that. Similarly he color-structured all the field equipment. While others sought the "right" upholstery, Girard employed a dozen related geometries so that the whole interior sang as a choir. He designed the graphics and terminal lounges complete with folk art collections.
In airline history, this was Camelot.

More than once Sandro described me as the "last of the handweavers." He was *not* a weaver, nor was he a craftsman in the sense of mastering skills to make objects—or textiles, for that matter. The fabrics he was most famous for are simple screen prints resulting from the direct application of his considerable graphic skills. At a time when many of us were using silk screening to achieve the soft fusion of color overlays on richly varied cloths so as to build up a "painted surface," Girard relied solely on his two-dimensional images and the juxtaposition of color. If today some of his fabric designs—such as the sun faces or those relying solely on juxtaposing pink with orange or green with blue—read as simplistic emblems of a period, many are more than that. These orchestrate several color values and intensities so as to build a layered depth. Often his simple motifs are modulated as well: one may have "fallen down," or, in another, a red heart playfully punctuates a field of geometric forms. Here, Sandro was creating visual songs. Other textiles were printed geometry so pure, timeless, and simple as to provide scale and an unmoving sense of materials to the too many spaces without these senses or sensibilities.

Best of all were his installations orchestrating many Girard patterns so the play was in the differences and similarities between cloths. The first to appear was a long series of small, sprightly jacquard geometrics for Herman Miller—mostly checks and triangles woven with highly con-

trasting dark-light neutrals or primary reds, greens, blues, and yellows against white grounds. They were best and most seen in Eames' installation of building-block cubes at the "Good Design" exhibition at MoMA in the early 1950s.

Girard's unique position in twentieth-century design is based in part on fabric design as only one aspect of his expression. More than most of us in fabric design, he is aware that the role of fabric is a *supporting* one. That Girard was an interior architect of great stature influenced his fabric design in a variety of ways. First of all, architectural commissions presented the challenge of fresh requirements—far beyond the conventions of a fabric collection *per se*. Often these commissions provided the impetus for a bold departure in Herman Miller's fabric line. Girard's interiors, widely published, were often perfect demonstrations of how to use his fabrics effectively.

As his own best client for fabrics, Girard describes the genesis of his cloths and colorings:

> *The simple geometric patterns and brilliant primary color ranges came to be because of my own urgent need for them on current projects. As you will remember, primary colors were frowned upon in those days; so were geometric patterns. I had the notion then, and still do, that any form of representational pattern, when used on folded or draped fabric, became disturbingly distorted, and that, therefore, a geometric pattern was more appropriate for a draped fabric. Also, I was against the concept that certain fabrics were "suited" to certain specific uses—like pink for girls or blue for boys!*

Picture, if you can, the time and setting of Girard's principal contributions, in the decades following WWII. After the disillusion of worldwide depression with the certain knowledge that WWI, "the war to end all wars," had not succeeded, the American heartland was first a flood-plain, then a dust bowl—abetting massive migrations within this

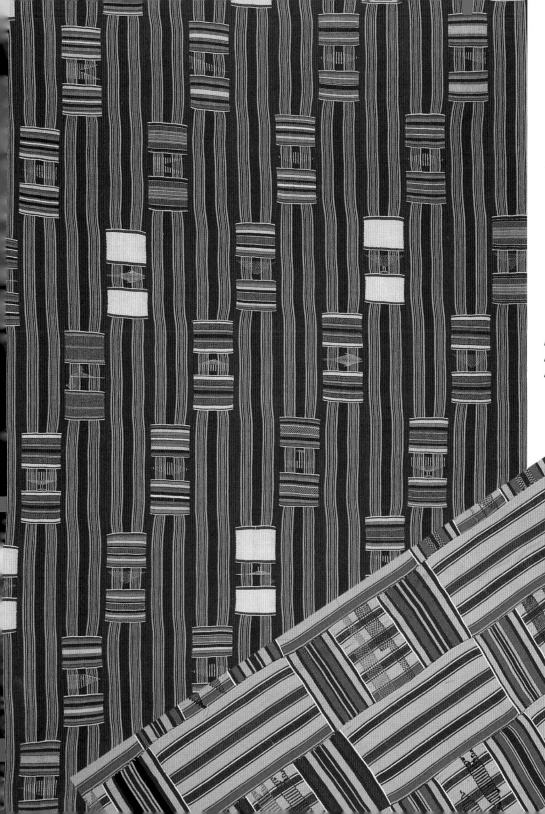

*Kente* Cloth (detail), Ewe People, Ghana or Togo, Africa, c. 1950.

*Kente* Cloth (detail), Asante People, Ghana, Africa, c. 1960.

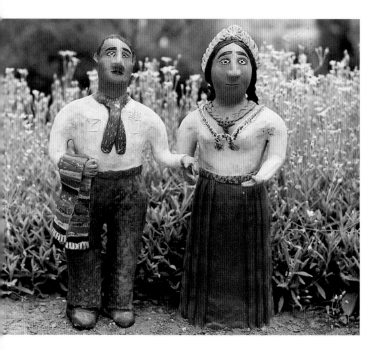

Bride and Groom, by the Aguilar Family,
Ocotlán de Morelos, Oaxaca, Mexico.
Photo by Charles Eames.

country. Then, arch-conservatism teamed with smug isolationist preju-
dices exploded into a world conflagration that would permanently bur-
den America with a sense of global responsibility. After WWII, with the
resumption of ocean crossings and the growth of global air transport,
there manifested many aspects of a new global view. After years of short-
ages and rationing, the Allies seemed for once less keen on world markets
than on sources of exotic imports unaffordable in the depression and
unavailable in years of conflict. Headlines and news releases had, for
years, featured far-away faces and created a keen interest in who and
where they were. Other points of view, including approaches to color,
sound, and dance, aroused our romantic fantasies, on the one hand,
or a new world order on the other. When it seemed that all peoples
alike deserved "the four freedoms," when we focused on "One World"
and spoke of the "Family of Man," we had come a far piece from the

Market Women, San Pedro
Tlaquepaque, Jalisco, Mexico.
Photo by Charles Eames.

complacent isolation of prewar decades.

The Girards' expanding folk art collections reflected all this, with durable expressions in a language deeper, older, and more moving than words. These crafts have much to do with the innate value of the pleasures of pattern, color, symbol, and surface. Repeatedly, the Girards were struck by similarities of expression in peoples far removed from each other. They had discovered the commonality of all people, especially those manifested in rural, agrarian societies.

Girard was a humanist, a student of the visual forces that move people, and especially of those that delight. He was Puck, a bright boy with many toys and games to share, magician and fairy godfather. He added fun to the matter-of-fact. Always in person, and most often in his work, the humor is as slyly thrown away as a boomerang. Through the corner of his eye, he awaited our reaction.

Procession, Quinua, Ayacucho, Peru, c. 1958.

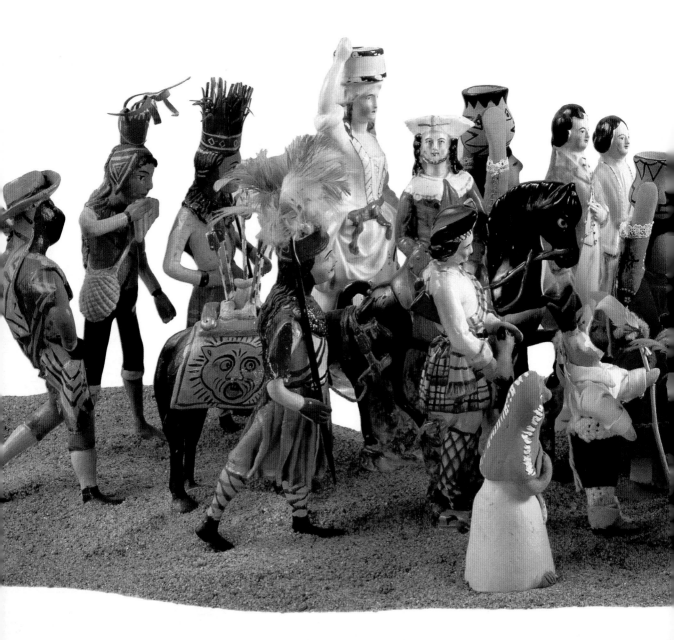

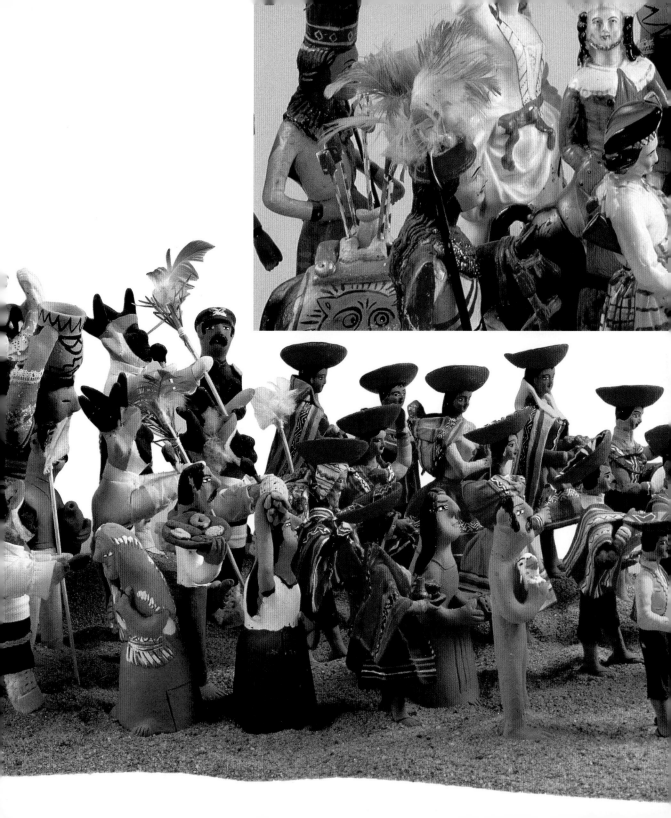

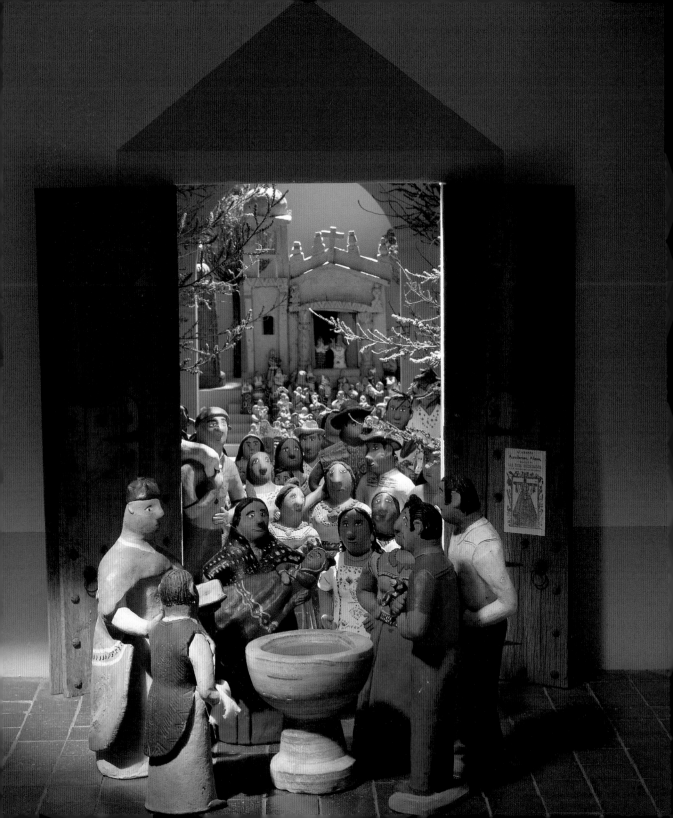

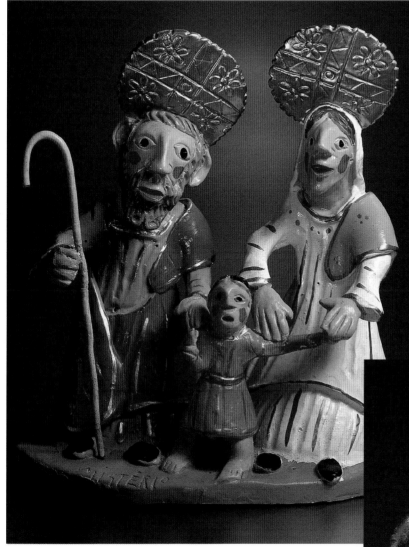

The Holy Family, by Domingos Goncalves Lima, called "Misterio." Barcelos, Braga, Portugal, c. 1960.

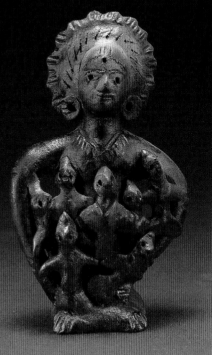

Votive Offering, Bengal, India, c. 1960.

◀ Baptism, by the Aguilar Family, Ocotlán de Morelos, Oaxaca, Mexico, c. 1960.

The Family of Krishna,
Northern India, late nineteenth
century.

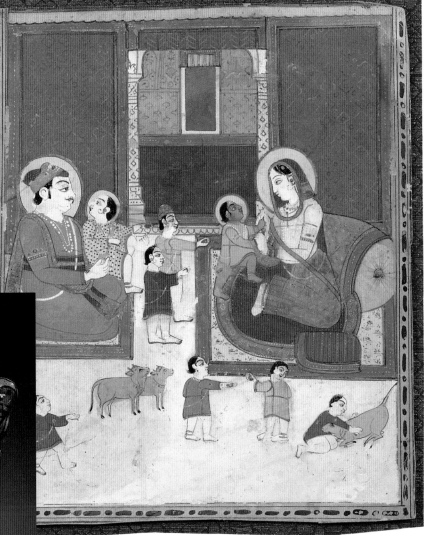

Mother and Child, Berber
people, Morocco, c. 1960.

Dineh (Navajo) Dolls, Arizona/
New Mexico Tribal Lands, c. 1960. ▶
Photo by Mark Schwartz.

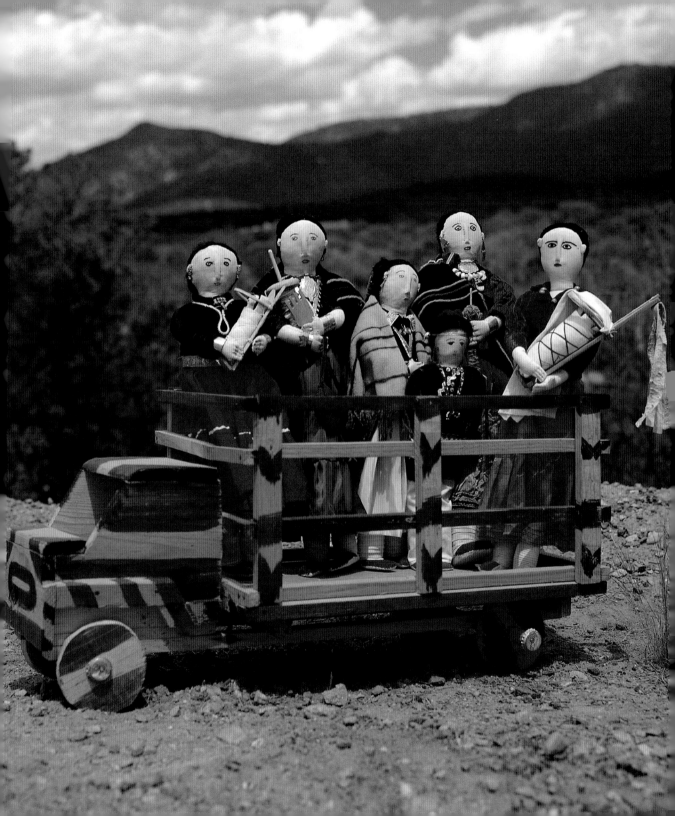

 By studying Japanese toys, one learns much about an intriguing culture that is at once progressive and steeped in its heritage. Historical and cultural implications can be seen in Japanese toys. From even the simplest playthings, captivating folklore emerges.

Folk toys today are mainly vestiges of the Edo Period (1603–1867) during which Japanese farmers, having become sufficiently prosperous and culturally aware, began to produce the variety of wonderful toys that are a part of the heritage of present-day Japan.

Today, although styles of toys vary from region to region, and a few localities produce unique toys, for the most part the same general themes are used repeatedly. Mainly, these themes predominate because the subjects are derived from traditional folk tales or Buddhist legends.

Japanese toys are made from a wide variety of materials, the most common being wood. A popular pastime in the farming villages on long winter evenings was carving, the favorite animal to carve being the horse, or *miharu-goma*. The simplified, rectangular shape made it possible to carve two horses from the same piece of wood, with little material wasted. The horse was then painted and covered with colorful designs. It is thought that a child who plays with the *miharu-goma* will be spared illness and that already weak children will become stronger.

One of the most common folk toys is the *kokeshi* doll from the Tohoku region. This simple doll, a wooden cylinder with a sphere set on top, was originally believed to have been presented at shrines by worshippers to insure the prosperity of their descendants. The variety of designs and facial expressions of the *kokeshi* dolls has enabled them to remain popular for more than a century, becoming today a collector's item as well as a toy.

Next to wood, the preferred medium for folk toys is painted papier-mâché. Many different

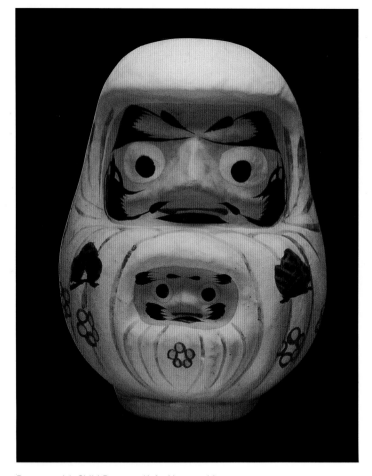

Daruma with Child Daruma, Kofu, Yamanashi, Japan, mid-twentieth century.

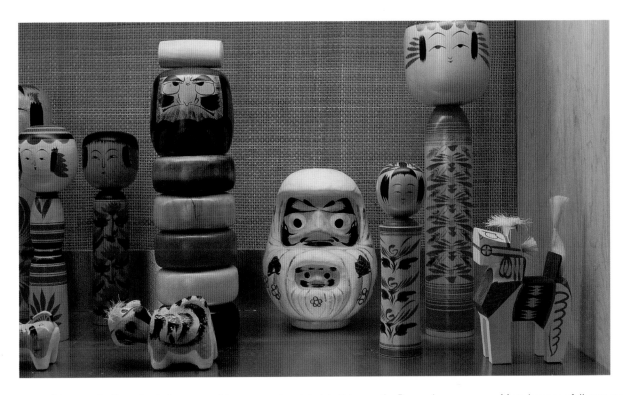

types of toys made throughout Japan use this material because it is lightweight and inexpensive. The *Daruma* is the most common. He represents the East Indian mendicant Bodhidharma, whose limbs were said to have withered away after he had sat for many years in constant meditation. Usually painted red, the Daruma is a round, hollow-bodied, self-righting image without arms or legs. He symbolizes fortitude, continued prosperity, and good fortune. Often he is purchased without eyes painted on by a buyer hopeful of receiving some good luck. When the desired luck comes, the owner paints on one eye; with another piece of good fortune, the second eye is painted. In this way, the Daruma's eyes are finally opened.

An unusual Daruma is shown here. The white Daruma holds a child Daruma, embellished by a black mustache to symbolize the hope that a son will achieve a higher position in life than his father. This type of Daruma has been made in Kofu, Yamanashi prefecture, since the seventeenth century. Always self-righting, this image makes a fascinating toy while at the same time promising its owner a better life.

Most Japanese folk toys are thought to have derived from ritual or supernatural beliefs. Japan, twentieth century. Photo by Mark Schwartz.

by CAROL STEIRO

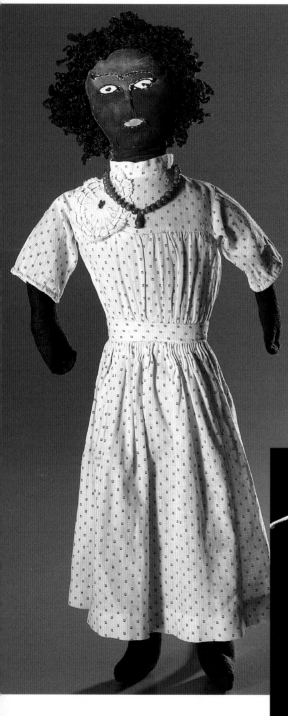

Doll, Eastern United States, early twentieth century.

With me it was really pretty simple: love of the objects came first, and there was absolutely no other criterion for collecting. What concerns me is an object's intrinsic value. And collecting for that reason is very different from acquiring things as if they were currency.

ALEXANDER GIRARD

Hand Puppets, Western Europe, late nineteenth–early twentieth century.

Embroidered Baby Shoes, China, early twentieth century.

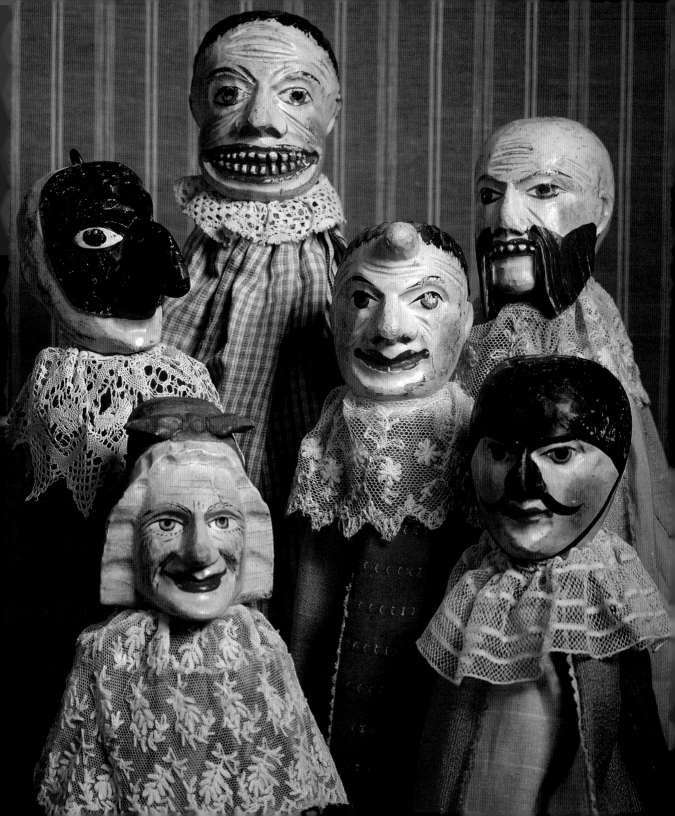

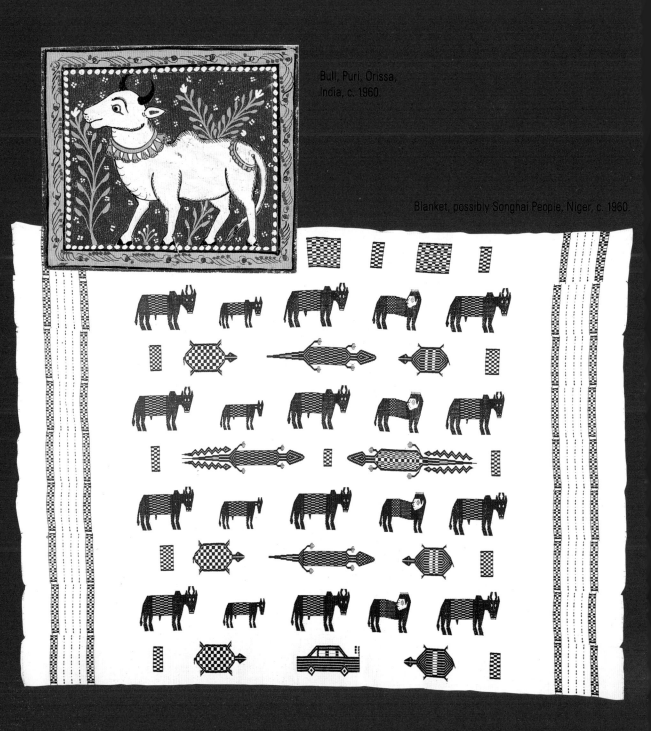

Bull, Puri, Orissa,
India, c. 1960.

Blanket, possibly Songhai People, Niger, c. 1960.

Lost Wax Brass (*dhokra*) Tiger with Rider,
Madhya, Pradesh, India, c. 1960.

Chalkware Cat, Pennsylvania, United
States, late nineteenth century.

Pueblo Scene: Corn Dancers and Church, by the Vigil Family, Tesuque Pueblo, New Mexico, c. 1960.

Coiled Basket, Crow Mother, Hopi People, Arizona, c. 1960.

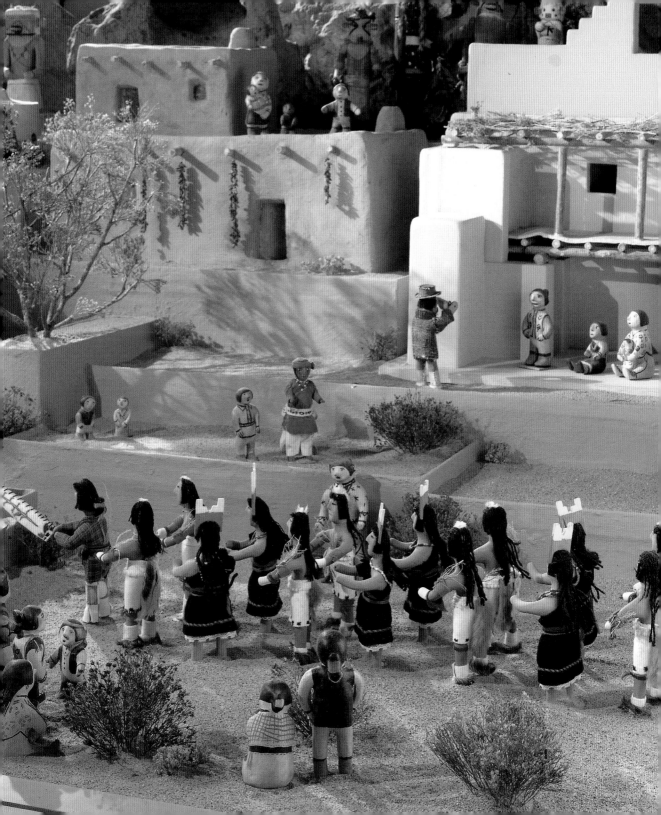

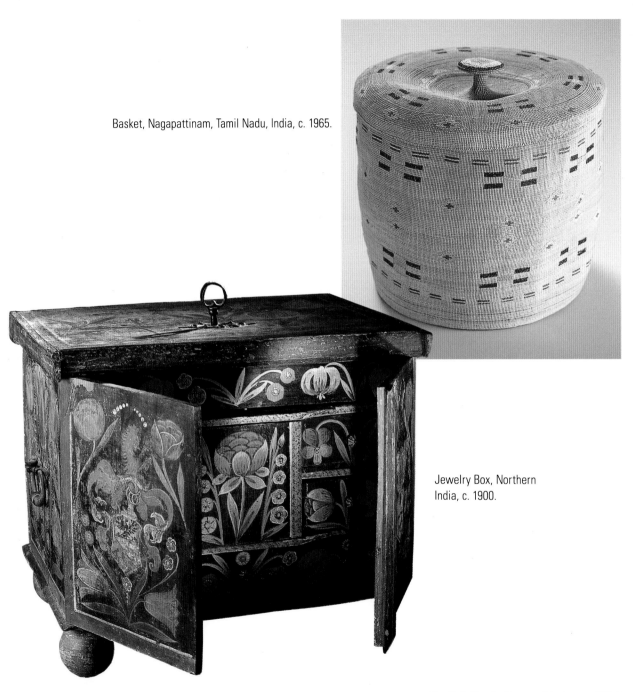

Basket, Nagapattinam, Tamil Nadu, India, c. 1965.

Jewelry Box, Northern India, c. 1900.

The Holy Family, Oaxaca, Mexico, c. 1960. ▶

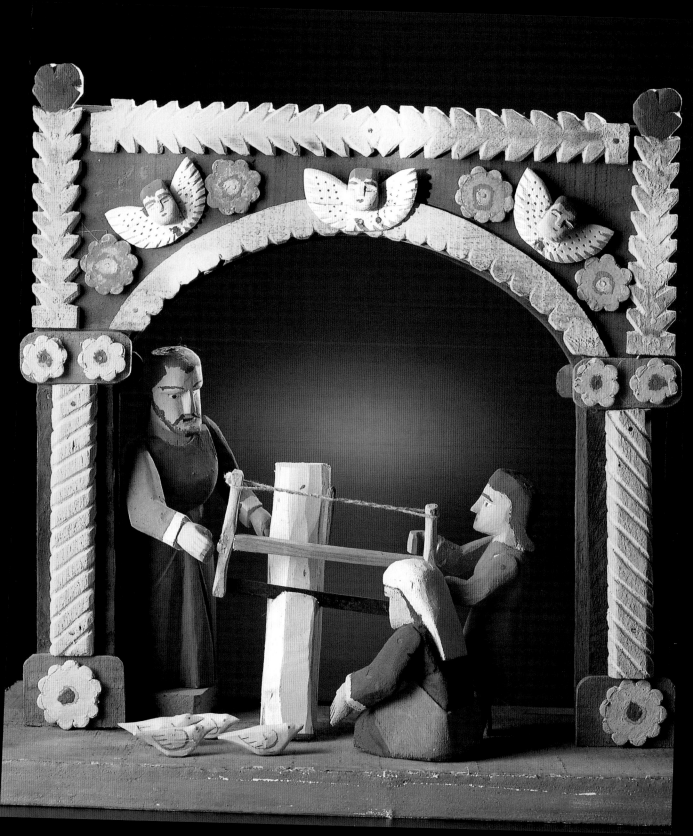

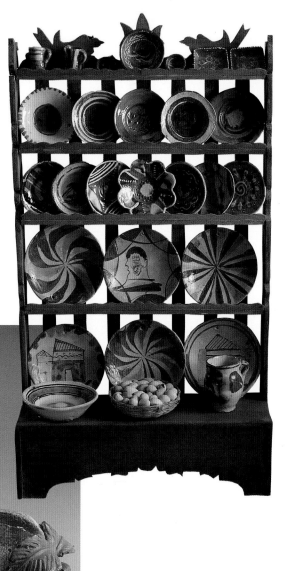

Miniature Dresser, Mexico, c. 1950.

Banks, San Pedro Tlaquepaque, Jalisco, Mexico, c. 1960.

48

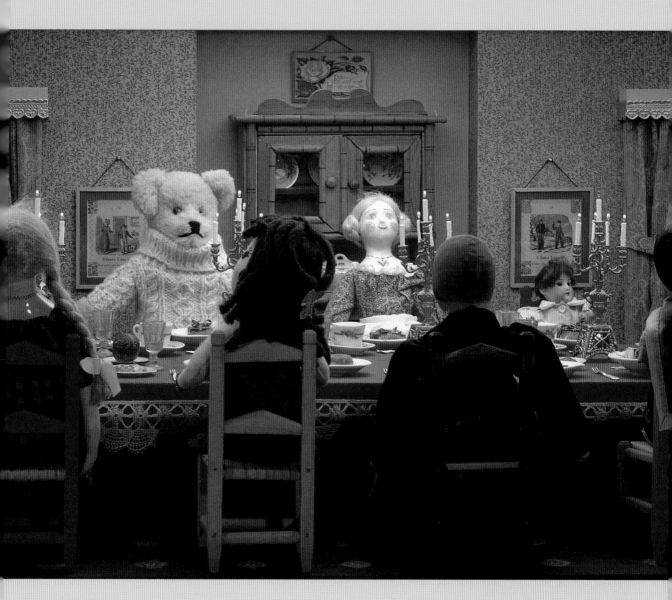

Dolls' Christmas Lunch, Europe and United States, nineteenth and twentieth centuries.

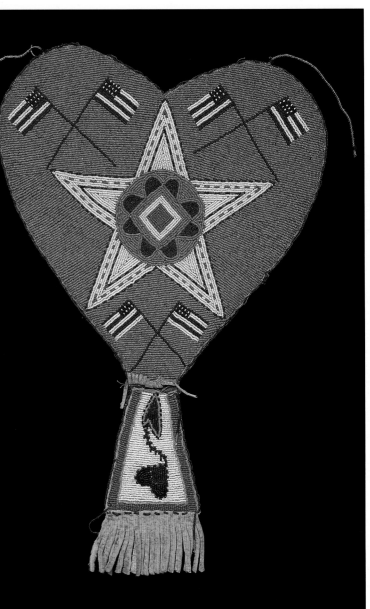

Native American Beadwork,
United States, c. 1968.

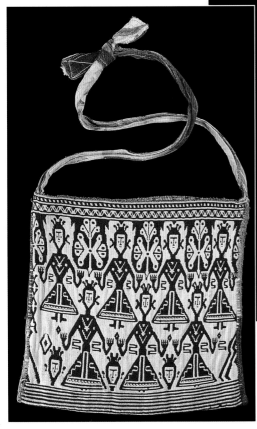

Bag, Otomí People, Toluca,
Mexico, c. 1930.

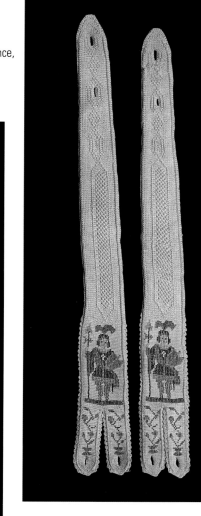

Suspenders, Florence, Italy, c. 1800.

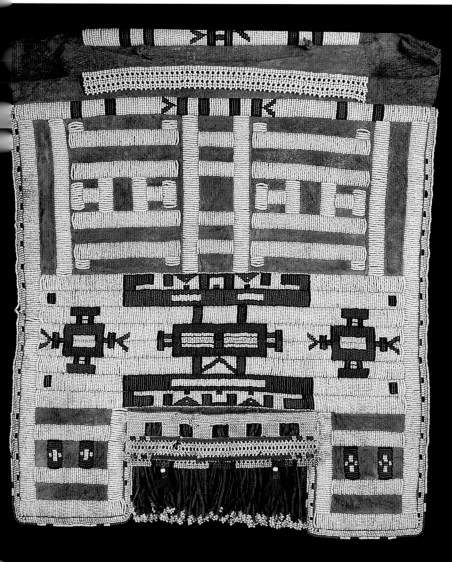

Apron, Ndebele People, Transvaal, South Africa, c. 1935.

51

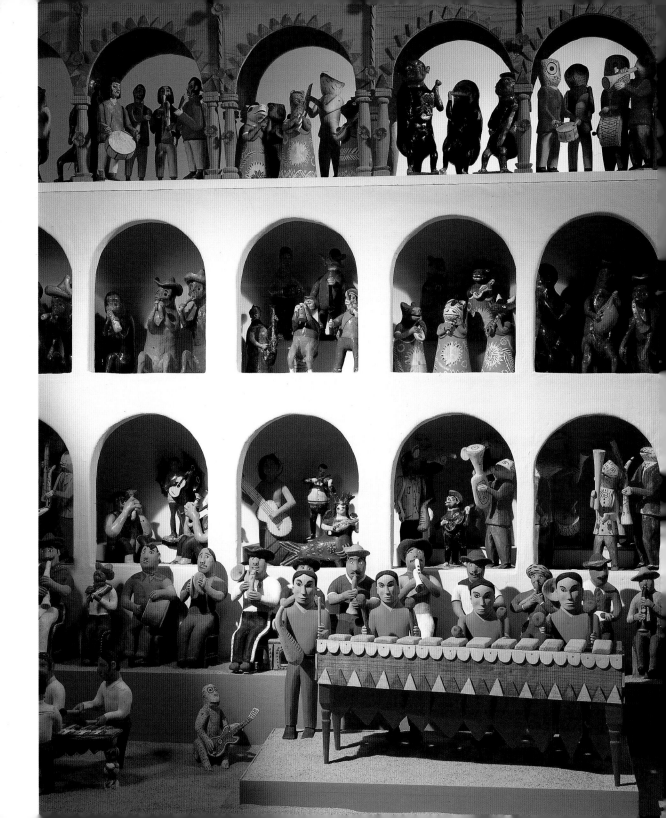

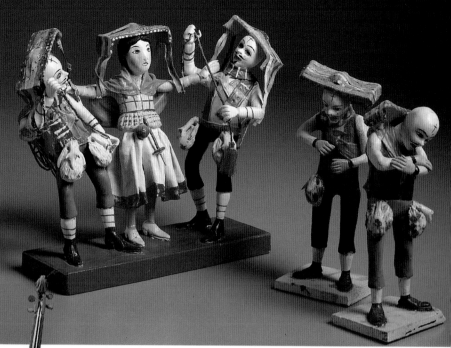

*Qolla* (ancient traders) Dancers, by Santiago Rojas, Cuzco, Peru, c. 1958.

Mexican Musicians, Ocotlán de Morelos and Coyotepec, Oaxaca, and Rio Balsas area, Guerrero.

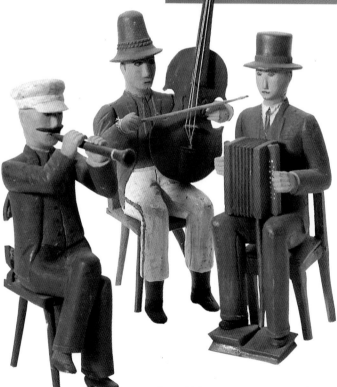

Carved Musicians, Poland, c. 1960.

Part of my passion has always been to see objects in context. As a collector who was often able to visit the workshop of the artist and see the actual environment in which a piece was made, I've often felt that objects lose half their lives when they are taken out of their natural settings. . . . I believe that if you put objects into a world which is ostensibly their own, the whole thing begins to breathe.

ALEXANDER GIRARD

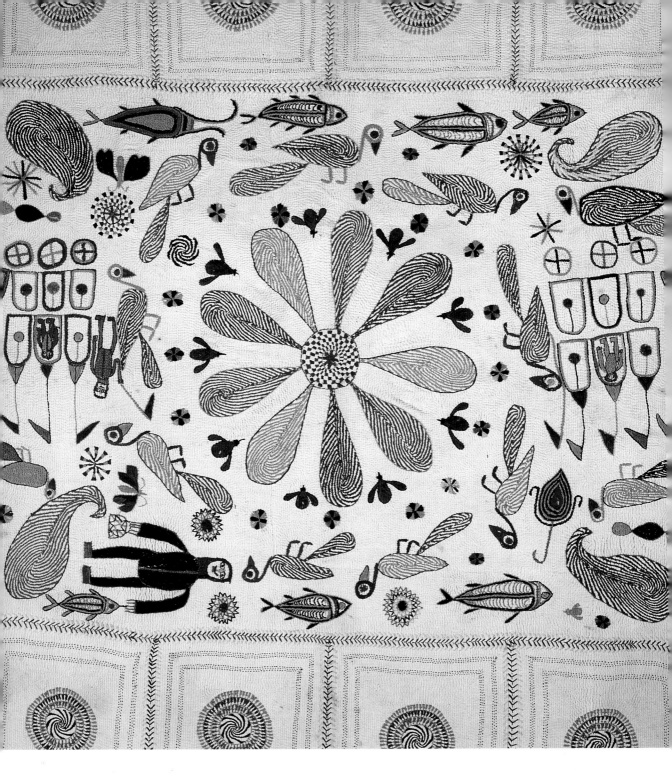

The center panel of this *kantha* textile from Bengal is not only a deeply personal expression of the maker but also a complex melange of traditional symbols. The simple central lotus; the *kalkas*, or symbols, of the tree of life at the four corners; the fish, birds, and butterflies; and the tiny circular motifs with swirls that are swastikalike sun and life symbols—all have Hindu and Buddhist meanings drawn from pre-Vedic roots native to the Indian subcontinent, dating back to as early as 2500 B.C.

Far more important than the visual symbols is the philosophy behind a *kantha*. It is made entirely of rags and tatters—something old and useless made new and whole. In the early Indian culture there was a magic quality to the complete and new textile, symbol of the complex forces of the universe. The ground cloth of the *kantha* was pieced of many layers—this textile has at least six—of thin, worn-out white *dhoti* fabric. The embroidery was worked entirely with colored yarns ravelled from the borders of saris. The stitches are extremely simple: darning and running stitch, stem stitch, and occasional looped and cross stitches. And, most remarkable, the embroidery is fully finished and complete on both faces—a profligate use of precious embroidery yarn, but so necessary when one has to make something ritually whole, perfect, and new from worn-out, tattered rags.

Aside from the American Indian textiles of my childhood home, the *kantha* was the first multipurpose, ritual tribal or village textile I encountered. I first learned of *kantha* textiles on a sunny, snowy New Year's Day when I was welcomed into a home filled with objects from India. Of her entire collection the many *kanthas* from Bengal were the most precious to my hostess. She spoke poetically and lovingly about these textiles—coverlets, shawls, baby carriers, and purses—which had been made as gifts originally to be used for personal daily ritual use. No examples of *kanthas* exist that predate the nineteenth century, because traditionally they were used literally until they were worn out, and although revivals have recently been successful the art of making *kantha* nearly died out during the first quarter of the twentieth century. The piece shown, one of four collected by Alexander Girard, is therefore unusual and rare.

Girard's four textiles illustrate a fair range of the art of *kantha*. Two of them are quite elabo-

*Kantha* Textile, West Bengal, India, late nineteenth century.

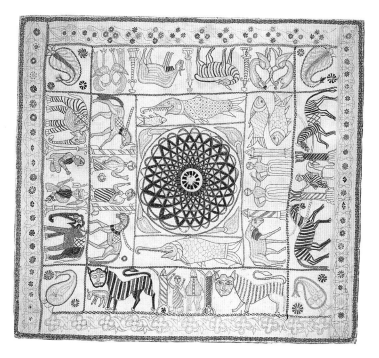

*Kantha* Textile from East Bengal, India, nineteenth century.

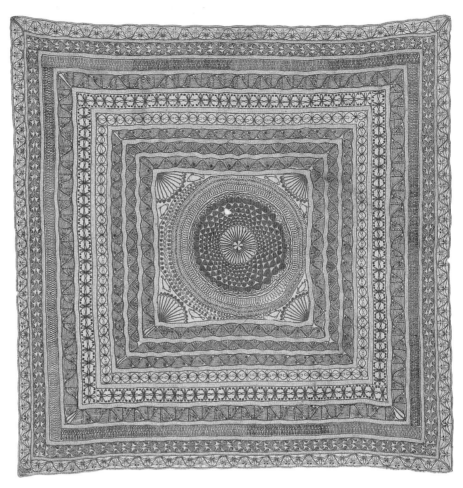

*Kantha*, East Bengal, late nineteenth century.

rate, yet the crudely drawn piece shown here, with its randomly placed animals, birds, temple cars, and smiling deities or men, wins my heart. As is typical, the central focus is the lotus, a Hindu and Buddhist symbol that originally was a pre-Vedic sign of the earth goddess. But, while there is a central focus, the panel teems with the diversity of life. Swirls form the lotus petals, the tails and bodies of birds, and the corner *kalkas*. Enigmatic elements such as the large, dark figure who stands at right angles to the rest of the composition—is this a fisherman, a Bengali deity, a local hero?—add to the diversity. Throughout, there is a three-dimensional quality to the piece, with unembroidered areas contrasting sharply with the tight, carefully worked embroidery.

I like the person who embroidered this textile—like her for her sense of humor and whimsy, for her careful sense of craft, and for her determination to say everything that she had to say.

by NORA FISHER

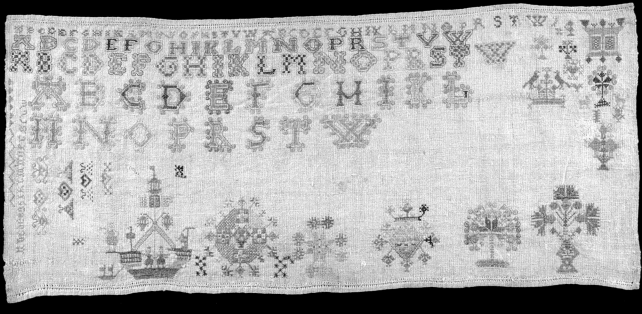

Sampler, The Netherlands, c. 1750.

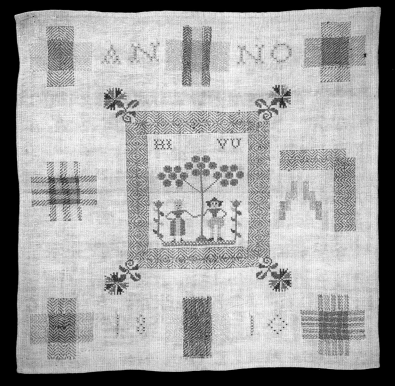

Sampler, The Netherlands, 1810.

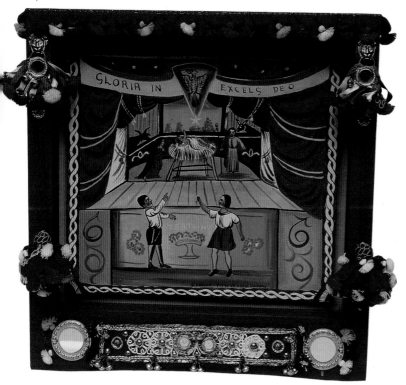

Toy Theater, by John Redington (1819–1876),
London, England, nineteenth century.

Juvenile drama has enjoyed several revival periods. It was a popular pastime for young men between the ages of ten and sixteen in nineteenth-century England. The construction of the toy theaters, complete with actors, scenery, and scripts, provided an imaginative outlet for these youths and lively family entertainment. The miniature theaters were replicas of London theaters, and dramas produced were taken from successful popular plays of the day. Along with the theater and sets, numerous pieces of stage equipment were required, such as metal slides for moving the actors, colza oil for the footlamps, and red, green, or blue "fire" and fire pans for the dramatic explosions.

The toy theaters reflect the daily life-patterns of the growing English middle class in the nineteenth century and the change in popularity from serious drama in the theaters to such forms as melodramas, musicals, and water spectacles. Enthusiasm for this type of entertainment is revealed by the popularity of souvenir portraits of actors from favorite plays. These portrait sheets often were carefully colored, embellished with tinsel and foil paper, and hung in the home.

There are numerous recollections and accounts of those who savored the joys of juvenile drama. Robert Louis Stevenson's essay "A Penny Plain and Twopence Coloured" is probably the most well known. From these accounts of juvenile drama, it may be gathered that the construction of the set for a performance was the most valued part of the production.

 It was during his school days in England that Alexander Girard first saw toy theaters such as this one, which was used to stage juvenile drama. (The term "juvenile drama" refers to toy theaters and the plays produced on their stages.) Throughout the years, he collected juvenile drama from England, France, Germany, Spain, and several other countries. The Girard Collection contains hundreds of theaters, character sheets, and scenery sheets.

by JUDY CHIBA SMITH

The ability to work found objects and mixed media into coherent compositions seems to be one of the universals of folk artists.

One contained, mixed-media object that has a history of strong appeal in the folk world is the crucifix in a bottle. The ship-in-a-bottle motif is, of course, familiar; however, equally popular in many places is the crucifix in a bottle surrounded by various symbols of Christ's Passion. The example illustrated here is from Germany (about 1900) but could as easily have come from France or another European Roman Catholic country. This theme is not confined to the Old World but finds great popularity in the Catholic countries of Latin America.

Besides the crucifix itself, there are many small objects placed behind, on, and around this central scene. Each of these little objects has a specific meaning within the context of the crucifixion. For example, behind the cross are the spear, sponge, and ladder, which, along with the hammer and pincers, refer directly to Christ's crucifixion. Other objects in the scene make reference to events leading up to and following the crucifixion, such as the cock that crowed after Peter's denial and the money box referring to Judas's traitorous act. Other frequently included objects would include dice, money, shroud, scourge, pillar, skull, nails, Christ's coat, cup, and wafer.

The example shown here includes some very nice decorative details, such as the sawtooth paper edging around the base and the cloth flowers. However, what carries this particular bottle out of the realm of the merely typical into that of the slightly bizarre is the inclusion of the upper torso and head of two small wooden dolls. The

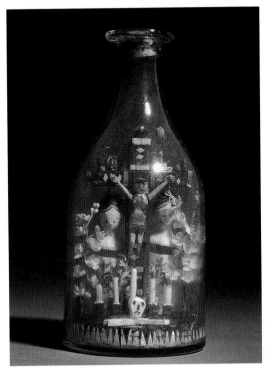

Crucifix in Bottle, Germany, c. 1900.

dolls are a type called "dutch dolls" and were made literally by the millions in Bohemia, Bavaria, and Saxony from the seventeenth century into the twentieth century.

These little doll parts are captured and preserved in a very strange setting. What do they have to do with this complex religious scene? Perhaps they are meant to stand in the place of two other very important players in the religious drama, the Virgin and St. John. Or could they be souls saved by Christ's redemption? Although such jarring visual incongruities are common in folk art, in any case these figures are certainly very unorthodox substitutes.

by CHRISTINE MATHER

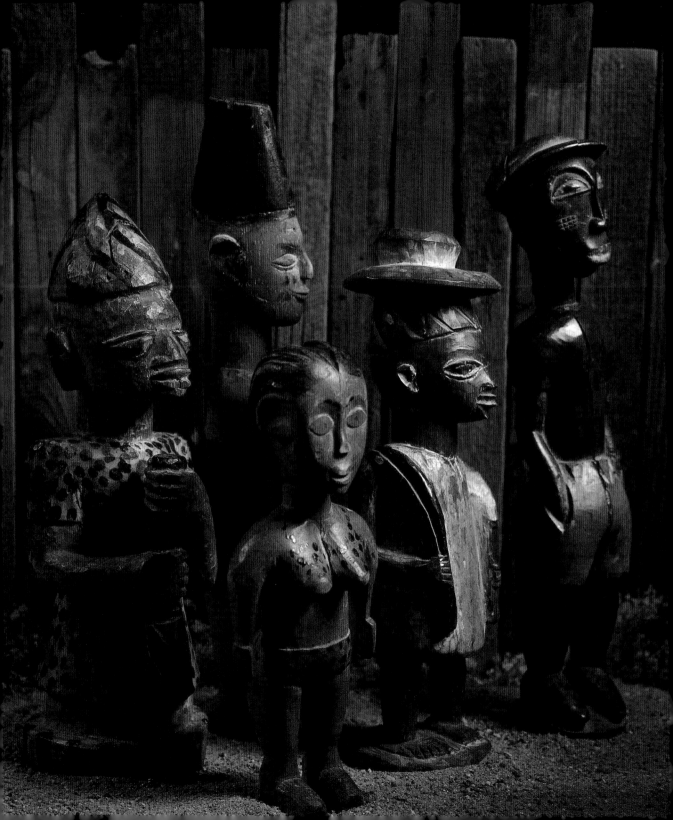

Alexander and Susan Girard made many buying trips to the continent of Africa, and additional pieces were collected through contacts with African art dealers. Their remarkable amalgamation of wooden carvings comes from the sculpture-producing area of Africa that extends over three thousand miles from Senegal to Angola. Within this vast area, each ethnic group has its own traditions reflected in a particular sculpture style. All of these sculptors are non-Muslims, for the Koran prohibits making images of people and animals. They live on fertile and arable land that is capable of producing trees and crops; these agriculturally based cultures are characterized by seasonal work cycles that provide blocks of time for carving as well as a sedentary life necessary for the accumulation of tools. Traditionally, each piece is commissioned and its carving executed by an apprentice with years of training.

The material products of a culture are inseparable from the very fiber of life within that culture; however, the viewer can appreciate African art without knowing the cultural context of each object. Louis T. Wells, writing in *Harvard*, found that there are aesthetic values common to both African and Western art. The workmanship must be judged on the basis of surface finish as well as balanced, strong, sure lines and mass, good composition and power of expression—qualities which must have appealed to the designer and artist in Alexander Girard. An exception to these principles would be the creation of objects portraying intentionally unaesthetic concepts such as disease and disorder. The African artist is not a naturalist but rather one who synthesizes and abstracts with emphasis on reduction of form for expression.

Figures of the Baule of the Ivory Coast were the first African sculpture to be appreciated in Europe. In the figures shown here an example of the carving of this culture is the figure on the left with the jockey cap and the short pants. Philip L. Ravenhill's studies show that these figures are representative of the "other-world lover" concept. Offerings to this other-world lover can affect the lives of the people for whom they were made. Viewed through the eyes of a Westerner, this figure might be regarded as an ethnic knick-knack. It might even be seen as "tourist art" because of its Western dress. However, although acculturation has occurred, the traditional aesthetics of the Baule prevail in the creation of this sculpture, particularly in the face and musculature of the limbs.

Both the figure next to the Baule carving and the carving on the far right were made by the Yoruba people living in Nigeria and Benin, formerly Dahomey. This culture is well represented in the Girard exhibit. The female figure is most likely from Togo. Wearing a fez is a carving from Senegal.

by MARY JANE SCHUMACHER

Carved Figures, Ivory Coast, Africa, c. 1970.

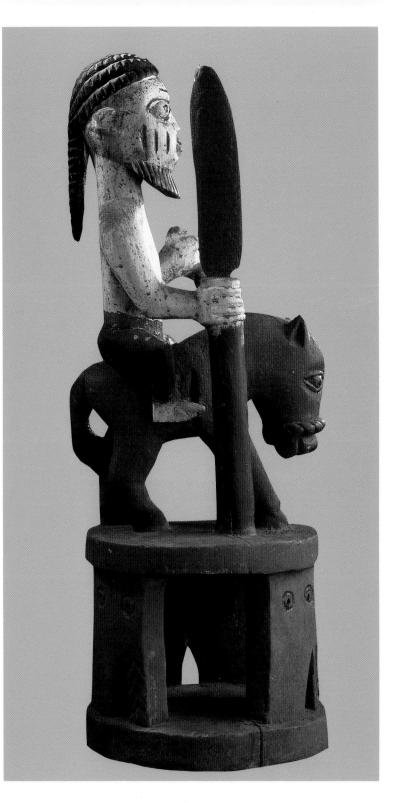

Horseman, Yoruba People,
Nigeria, c. 1960.

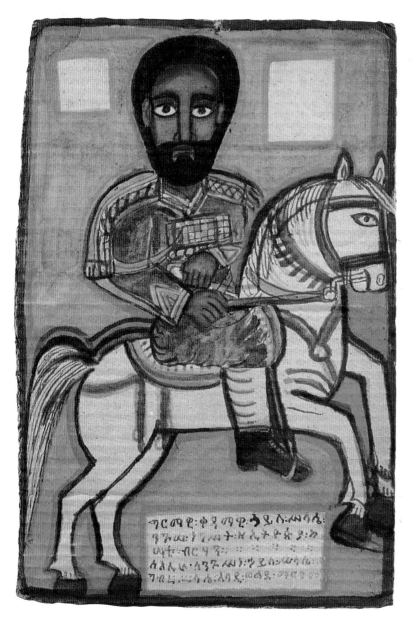

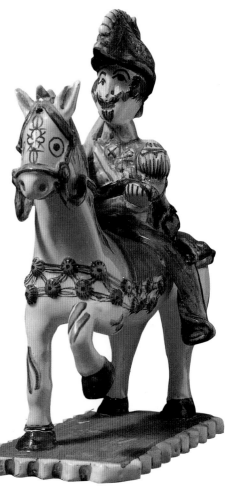

Haile Selassie, Lion of Judah,
Emperor of Ethiopia, 1930–74.
Central Ethiopia, c. 1965.

Horseman, Spain, c. 1950.

Horse, Nagano, Japan, c. 1960.

◀ Horse Toy, Bangladesh, c. 1960.

Carved Horse, India, nineteenth century.

Commercial Resist-dyed Cloth, Nigeria, Africa, c. 1960.

Manta (carrying cloth), Ayacucho, Peru, c. 1960.

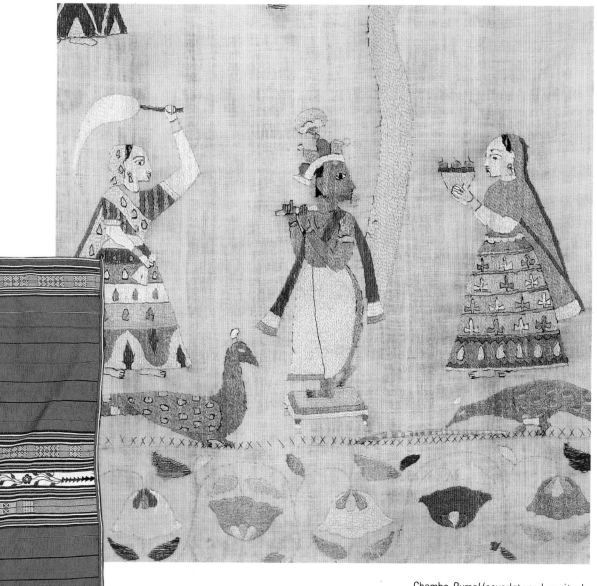

Chamba *Rumal* (coverlet used on ritual occasions), Himachal Pradesh, India, mid-nineteenth century.

*Phulkari* (ceremonial headdress), Hazara District, Pakistan, c. 1900.

*Raffia* (embroidered ceremonial headcloth), Shoowa People, Kasai River area, Zaire, c. 1935.

*Raffia* Cloth (detail), Kuba People, Kinshasa, Zaire, c. 1970.

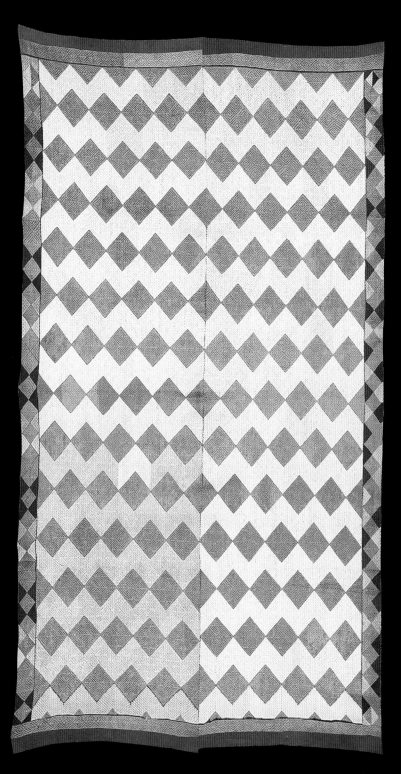

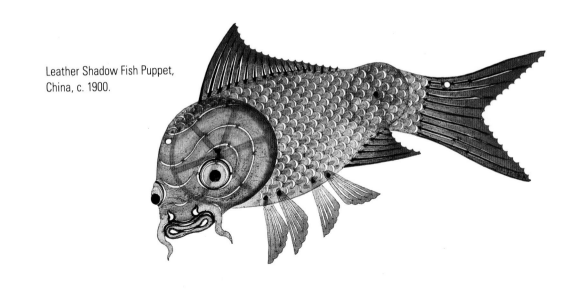

Leather Shadow Fish Puppet,
China, c. 1900.

Wooden Elephants, Sri Lanka, c. 1958.

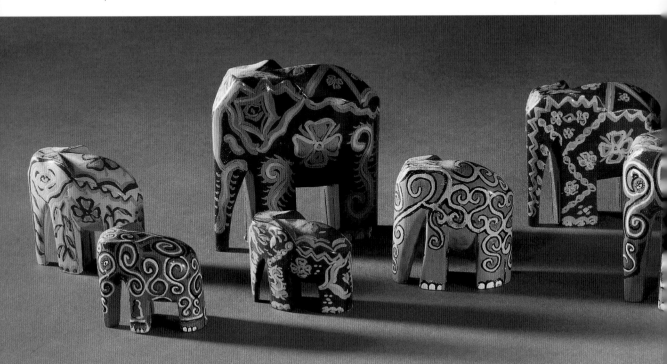

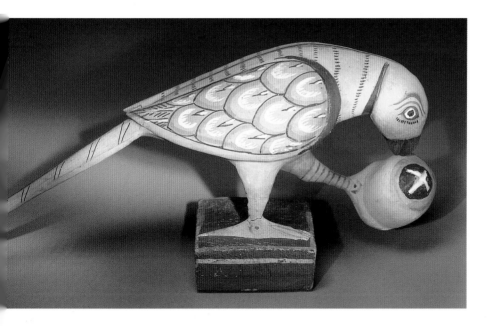

Parrot, Kondapalli, Andhra Pradesh, India, c. 1960.

Papier-mâché Snake in Mango, India, c. 1970.

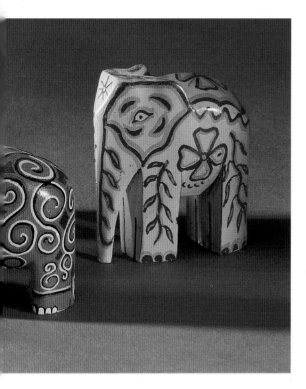

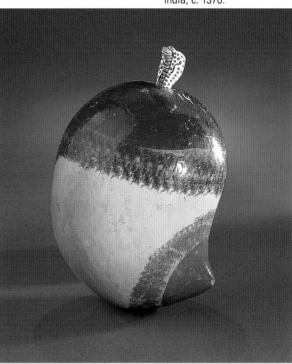

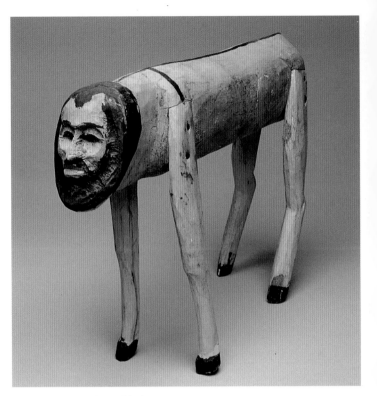

Horse with Man's Face, Mexico.
Photo by David Knight.

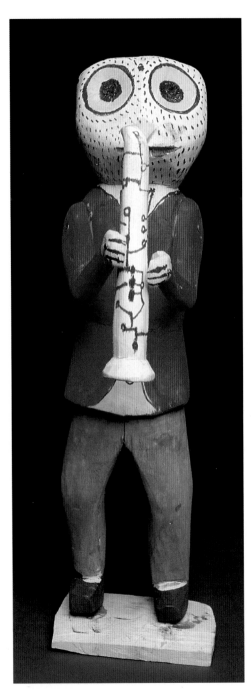

Flute Player, Oaxaca, Mexico. Photo
by David Knight.

I like to provide visitors
with something to hang
on to, like color, texture
or situations, because in
the end, I don't believe
most folk art objects are
great masterpieces. . . .
I do think there are mas-
terpieces within tradi-
tions, but there *is* such a
thing as "junk" folk art.
It is possible to judge
quality in folk art just
as you would in fine art.

ALEXANDER GIRARD

Jaguar Mask,
Mexico, c. 1960.

Cow with Man's Body, Celaya,
Guanajuato, Mexico, c. 1960.

Huichol Yarn Painting, Nayarit or Jalisco, Mexico, c. 1978.

Embroidered Wall Hanging (detail), Hausa Region, Nigeria.

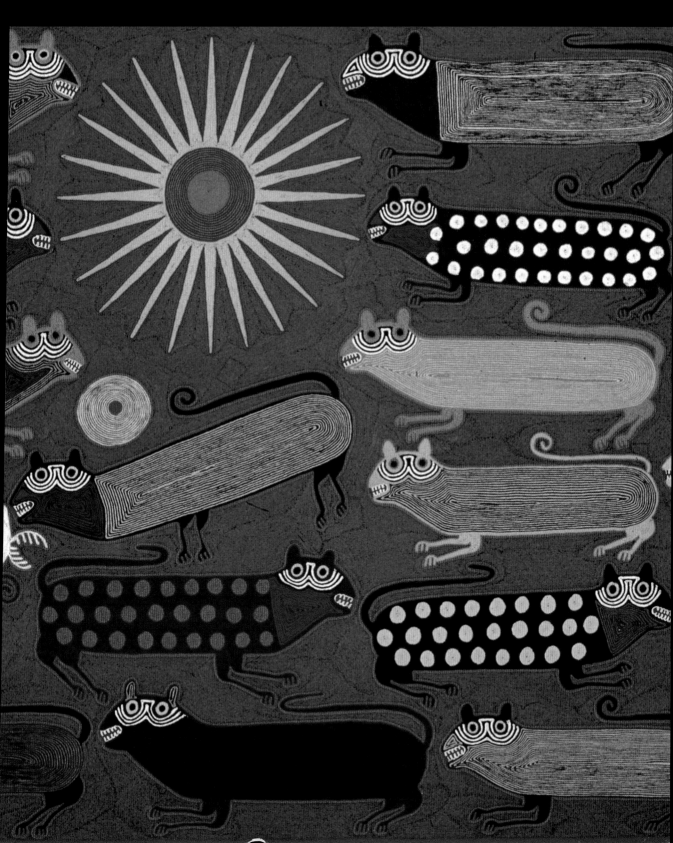

The Jagannatha Deities,
representing Hindu Krishna
figures, Puri, Orissa, India, c. 1960.

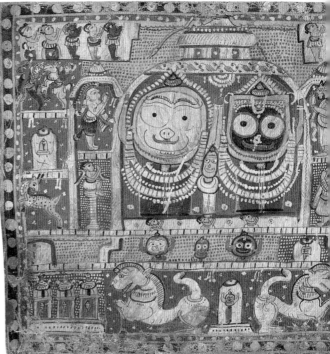

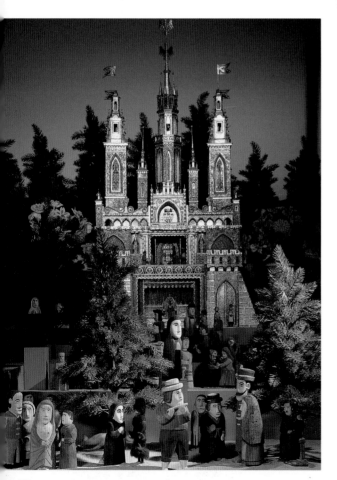

Procession with *Szopka* Model
Manger, Poland, c. 1960.

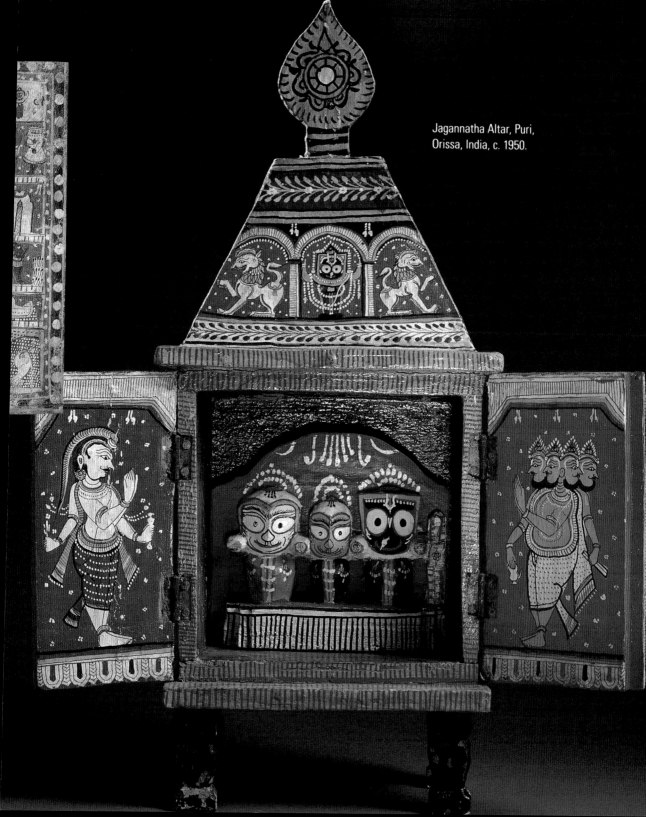

Jagannatha Altar, Puri,
Orissa, India, c. 1950.

I began to ask myself, "What is wrong with me that I like this stuff?" Now I suppose it's because each expression is at once so personal and so universal. The people who make the things I collect often live in squalor. And yet, we live in a greater aesthetic squalor than they do.

ALEXANDER GIRARD

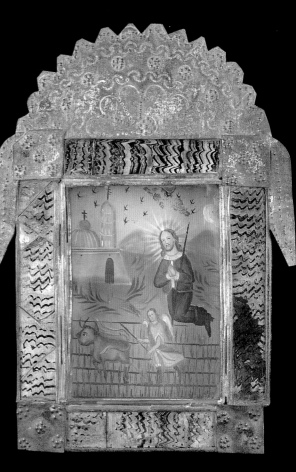

Saint Isidore/San Ysidro Labrador, the patron saint of farmers, Mexico, mid-nineteenth century.

Holy Men, by N. Giasiranes, Greece, c. 1960.

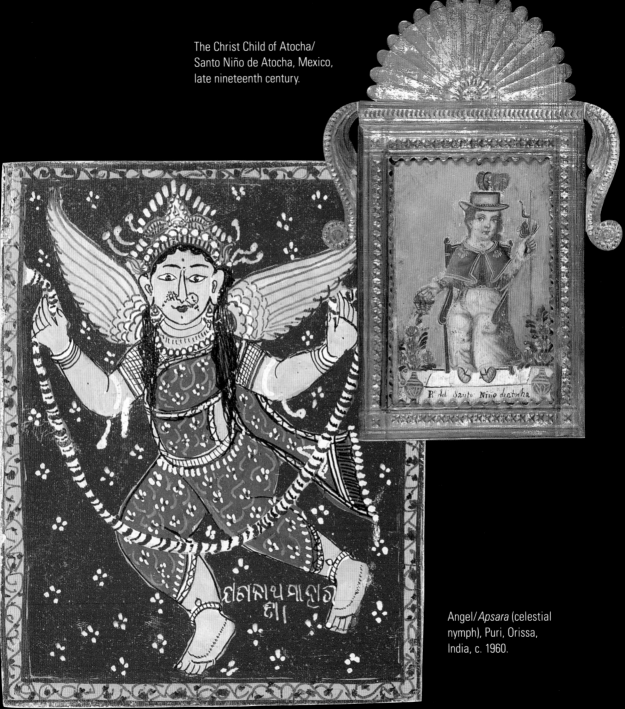

The Christ Child of Atocha/ Santo Niño de Atocha, Mexico, late nineteenth century.

Angel/*Apsara* (celestial nymph), Puri, Orissa, India, c. 1960.

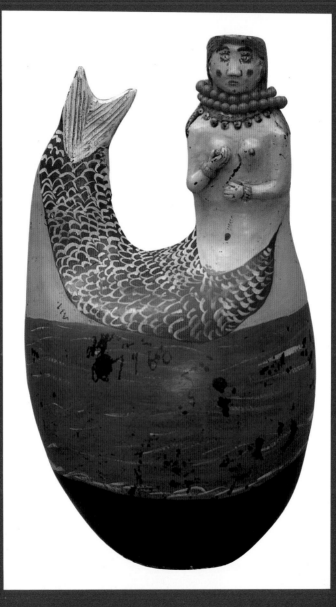

Mermaid Jar, San Bartolo Coyotepec, Oaxaca, Mexico, c. 1935.

 This mermaid jar was once used as a decanter for *mescal*, the distinctively Mexican liquor made from the agave cactus. It was acquired by Alexander Girard for his collection after he discovered it sitting in the window of a mescal shop in the southern Mexican city of Oaxaca. The jar most likely was made in the 1940s in the nearby Zapotec Indian village of San Bartolo Coyotepec, a site well known throughout Mexico for its burnished black pottery—and its mermaid jars.

The mermaid has a long and somewhat unexplained history in Mexico and other parts of Latin America. While mermaids were introduced to the indigenous peoples of the Americas by their Spanish conquerors, for whom their very real existence was more or less accepted—Columbus himself reported seeing three on January 9, 1493, noting they "rose well out of the sea, but were not so beautiful as they paint them. . . ."—the reasons for their continued popularity among landlocked Indian populations of Mexico, Guatemala, and the Andes remain a mystery. Perhaps this mythological figure, once transformed into a symbol of vanity and vice by Christian medievalists, was later identified with pre-Columbian water deities by the reluctant indigenous converts. Even today the mountain-dwelling Otomí Indians of the Puebla highlands in Mexico worship a rain spirit whom they call *La sirena*—mermaid—and make propitiatory offerings to her when their crops are threatened by either a scarcity or overabundance of rainfall. We also know that every year literally thousands of mermaids in the forms of whistles, jugs, and figurines are produced in Mexico—many of them destined for markets in the United States.

The mermaid jar shown has an unusual "paint job." Notice how ingeniously the artist has made the pot a vehicle, in effect, for the painting. The black band at the bottom is the unpainted shiny black surface that once was visible over the entire surface of the pot. The painted blue band above it depicts the sea, over which the mermaid

seems to skim effortlessly. Her scaly lower torso curvaceously reflects the shape of the overall form, terminating in a flashy metallic gold tailfin backed by a cloudless azure sky.

Never one to forget her primary purpose of luring sailors to a watery demise (or perhaps drinkers to drown themselves in drink?), this mermaid is well adorned with an elaborate necklace and two bracelets of clay. The strand of orange plastic beads around her neck is likely an affectionate later addition made by a previous owner.

A quality that sets this piece apart is the temptress' sullen expression and brazen gesture. With painted cheeks and eyelashes, she offers her breast seductively, yet the blank stare and pouty mouth cause one to wonder: Is this *femme fatale* suffering from ennui? Is she so blasé as not to care about the fate of yet another victim? Or is this perhaps a being whose one wish would be to reconcile her human and animal natures once and for all—a mermaid yearning for freedom from her existential plight? One thing, at least, is certain: this provocative lady will *never* tell.

by CHARLENE CERNY

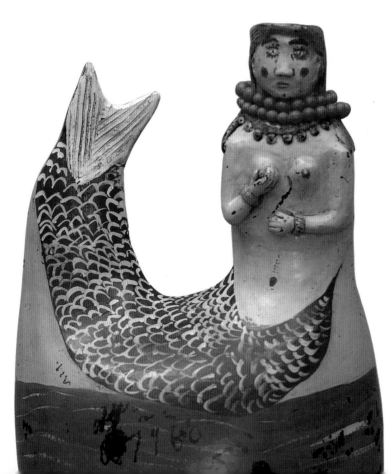

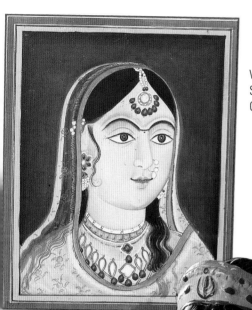

Rajput Lady, Northern
India, late nineteenth
century.

Woman, by Teodora Blanco,
Santa María, Atzompa, ▶
Oaxaca, Mexico, c. 1965.

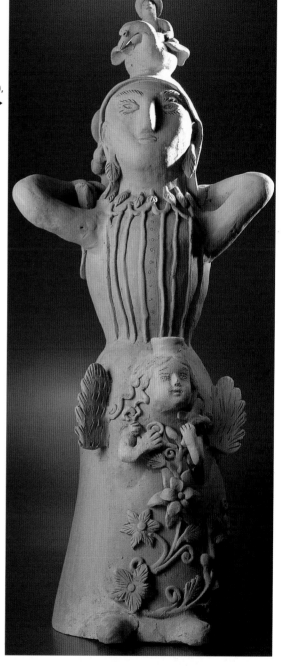

Empress Josephine,
Eastern United States,
mid-nineteenth century.

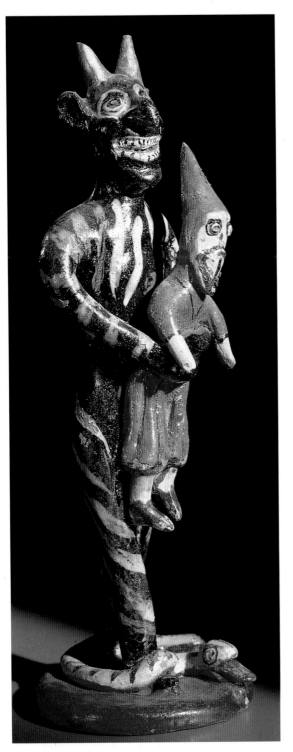

Devil, Ocumicho, Michoacán,
Mexico, c. 1960.

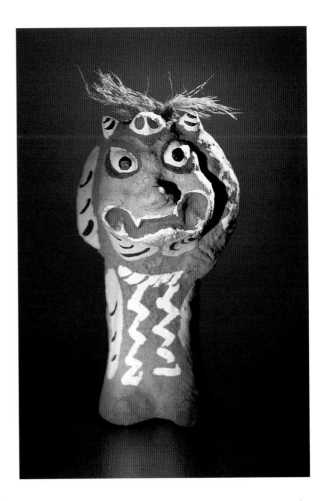

*Oni* (Demon), Aomori,
Aomori Prefecture,
Japan, c. 1960.

Devils, Mexico, Portugal, and ▶
Brazil, c. 1960.

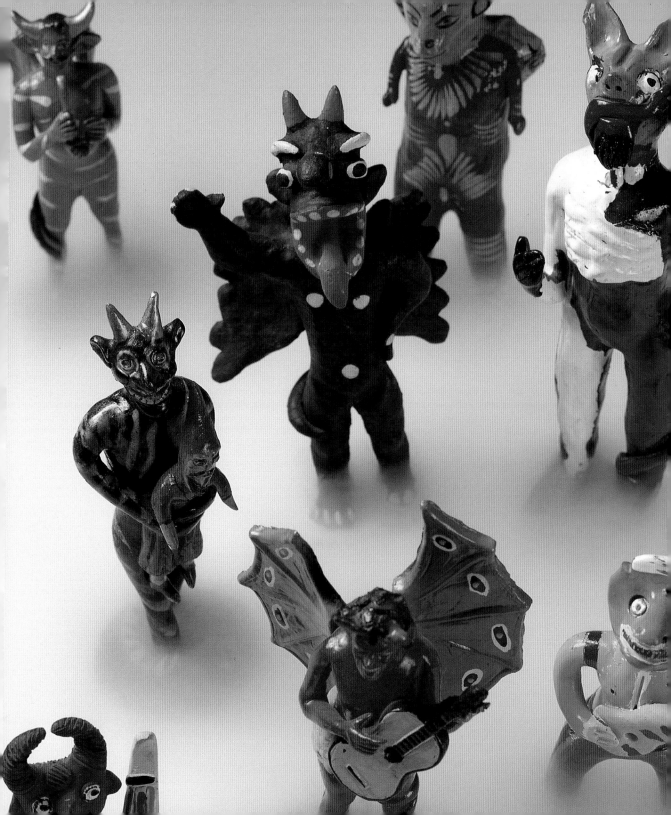

Cross of Souls/*Cruz de Animas*,
Mexico, nineteenth century.

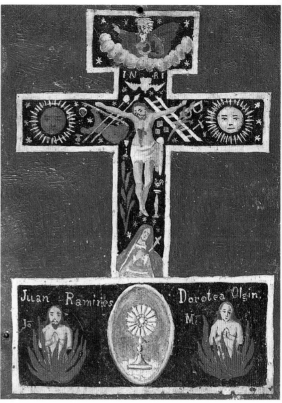

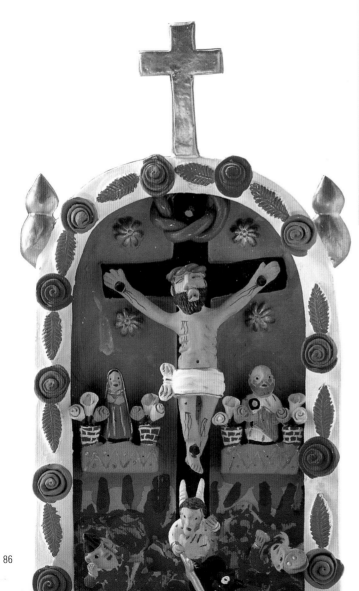

The Crucifixion, by Domingos
Goncalves Lima, called
"Misterio." Barcelos, Braga,
Portugal, c. 1960.

Altar for the Day of the Dead, ▶
by David Villafañez, Oaxaca,
Mexico, c. 1960.

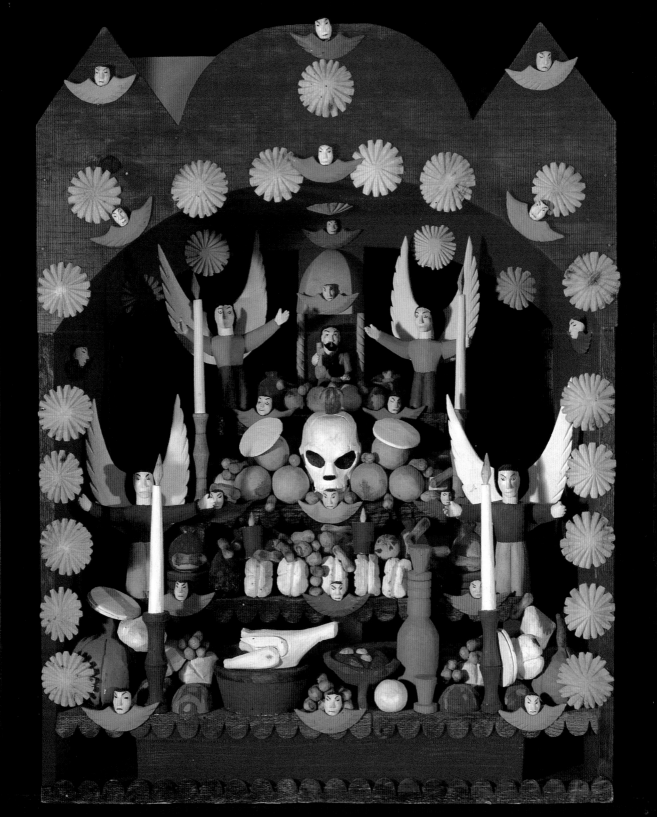

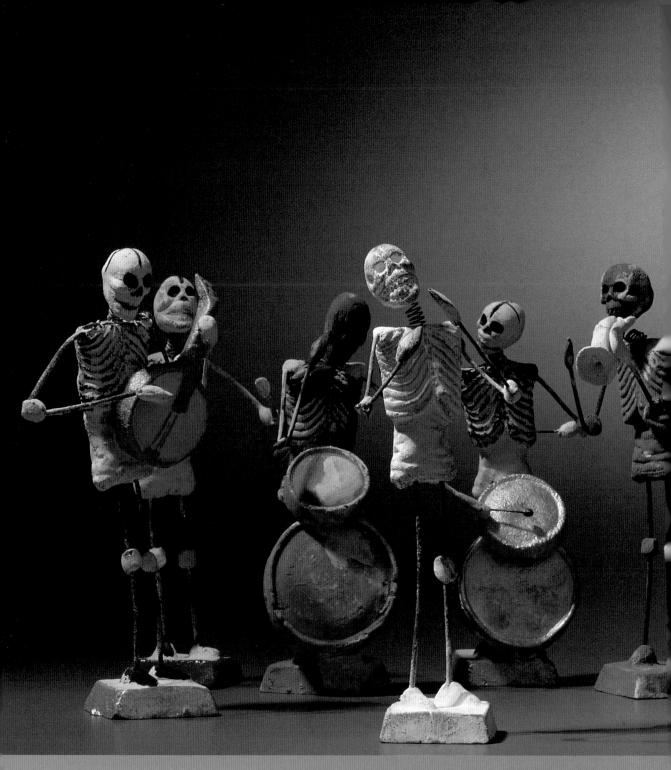

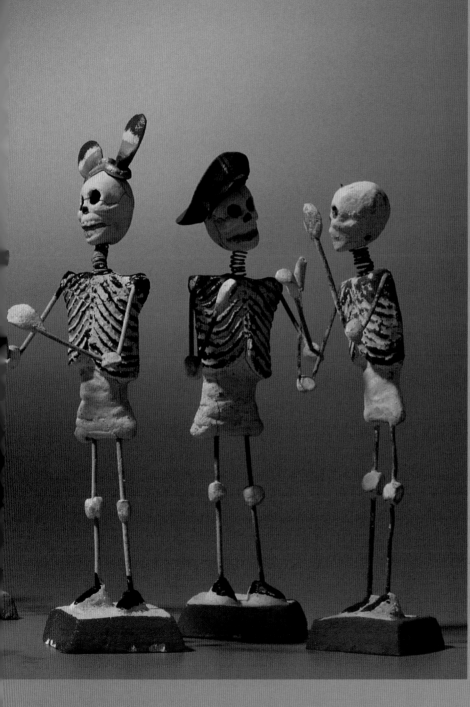

Skeleton Orchestra, State of
Mexico, Mexico, c. 1956.

Skeleton, Mexico, c. 1956.

Graveyard, painting by
Alberoi Bazile, Port-au-Prince,
Haiti, 1967.

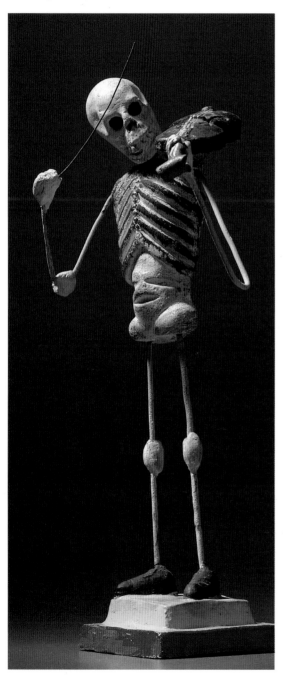

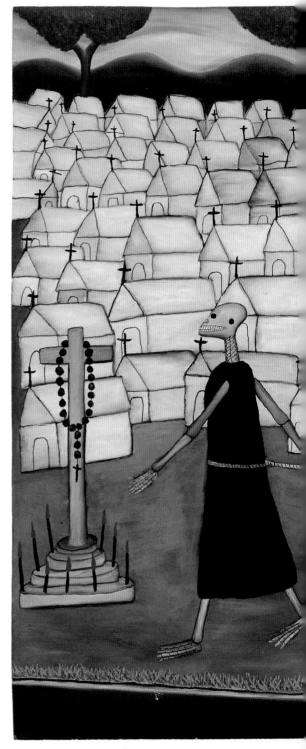

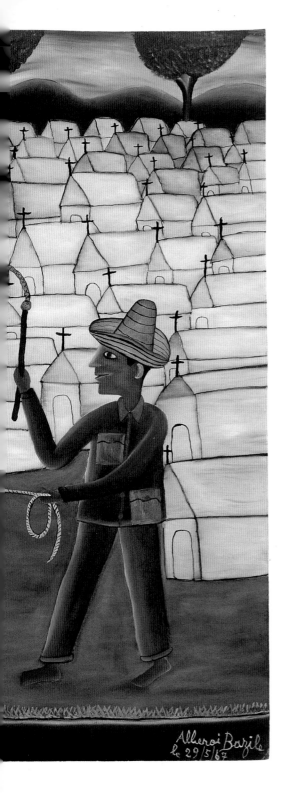

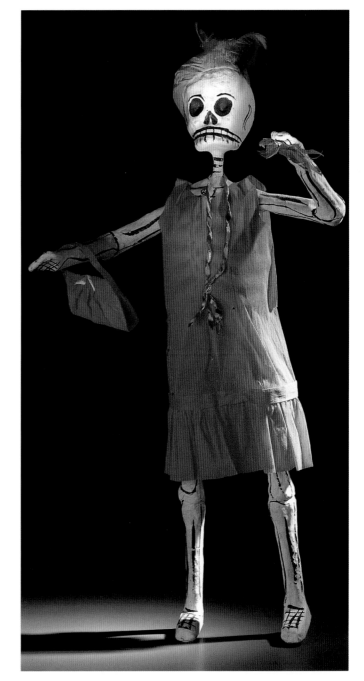

Skeleton, Celaya, Guanajuato,
Mexico, c. 1965.

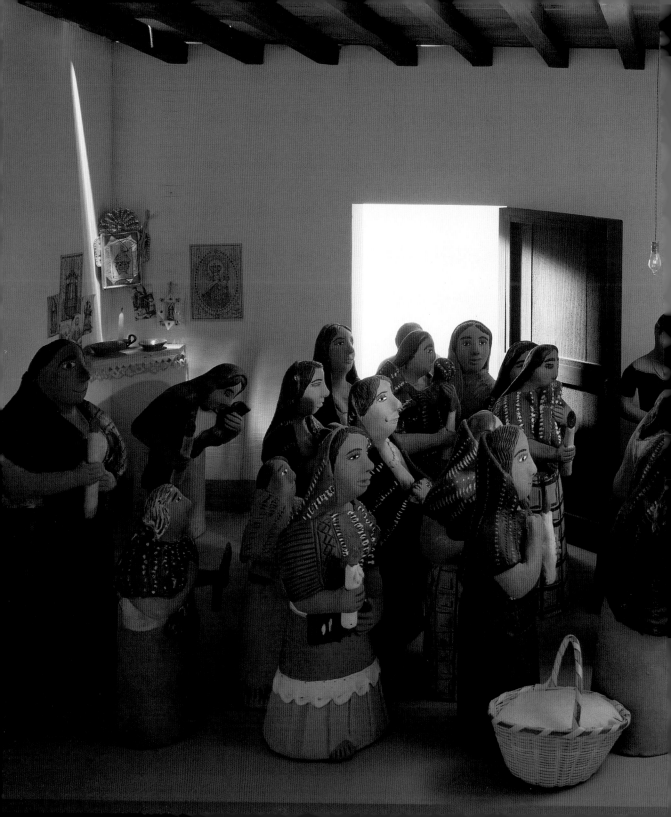

Wake, by the Aguilar Family, Ocotlán de Morelos, Oaxaca, Mexico, c. 1960.

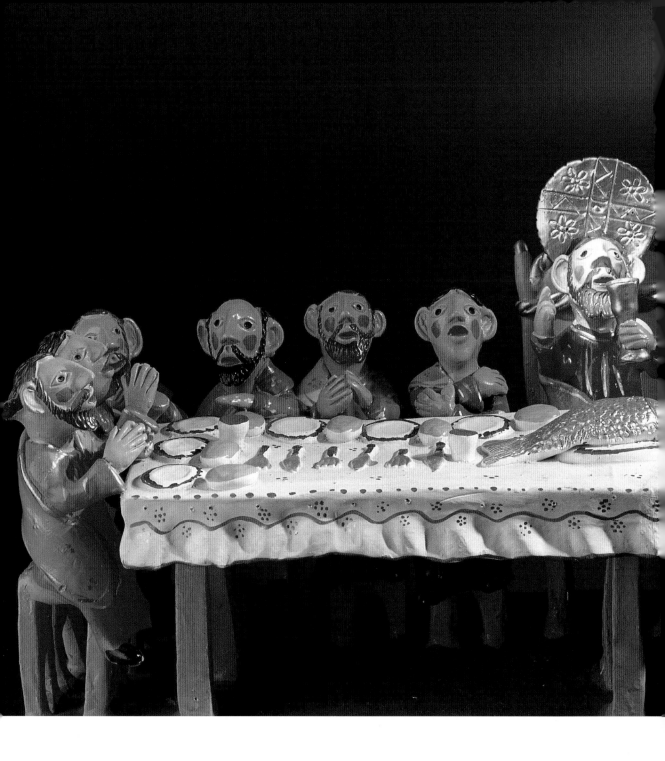

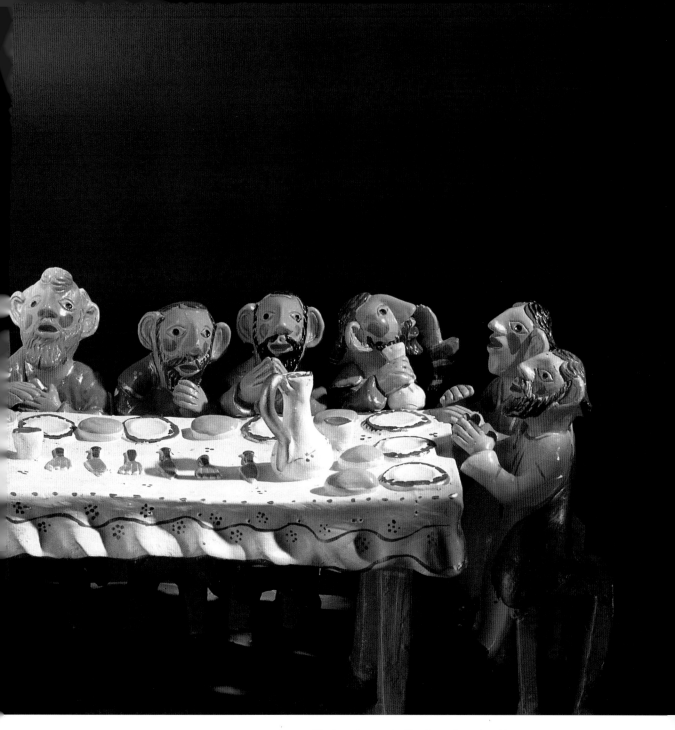

The Last Supper, by Domingos Goncalves Lima, called "Misterio."
Barcelos, Braga, Portugal, c. 1960.

Bank, Tonalá, Jalisco,
Mexico, c. 1960.